Brushwork ESSENTIALS

How to render expressive form and
texture with every stroke

MARK CHRISTOPHER WEBER

NORTH LIGHT BOOKS
CINCINNATI, OHIO
www.artistsnetwork.com

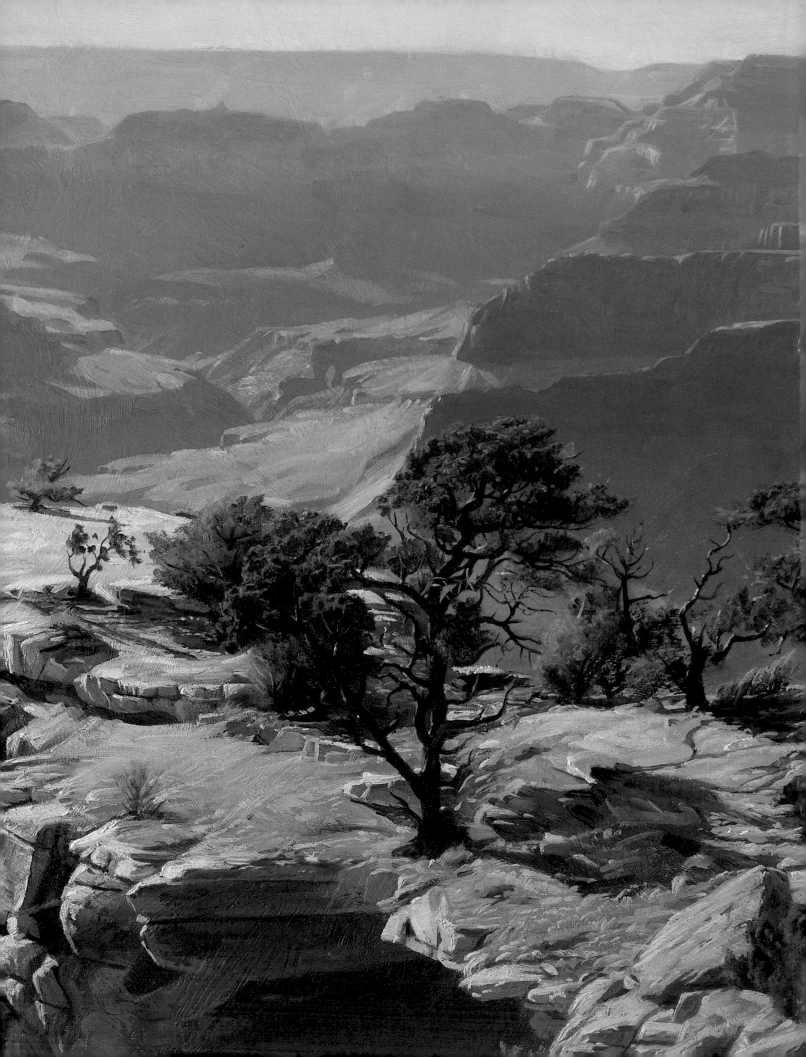

Brushwork Essentials. Copyright © 2002 by Mark Christopher Weber. Manufactured in China. All rights reserved. No part of this book may be reproduced in any form or by any electronic or mechanical means including information storage and retrieval systems without permission in writing from the publisher, except by a reviewer who may quote brief passages in a review. Published by North Light Books, an imprint of F+W Publications, Inc., 4700 East Galbraith Road, Cincinnati, OH 45236. (800) 289-0963. First Edition.

Other fine North Light Books are available from your local bookstore, art supply store or direct from the publisher.

06 05 04 03 02 5 4 3 2 1

Library of Congress Cataloging in Publication Data
Weber, Mark Christopher
 Brushwork Essentials : how to render expressive form and texture with every stroke / Mark Christopher Weber.— 1st ed.
 p. cm
 Includes index.
 ISBN 1-58180-168-8 (hc. : alk. paper)
 1. Brushwork. 2. Painting—Technique. I. Title.

ND1505 .W43 2002
751.4—dc21 2001052162

Edited by James A. Markle
Designed by Wendy Dunning
Layout by Joni DeLuca
Production coordinated by John Peavler

DEDICATION

Dear Randi, for your faith, commitment, patience, love and help, I want to dedicate this book to you. Let's keep on plugging ahead.

THREE WINDOWS
Oil on panel
24" × 20" (61cm × 51cm)
Collection of Tom and Imogene Booth

METRIC CONVERSION CHART

To convert	to	multiply by
Inches	Centimeters	2.54
Centimeters	Inches	0.4
Feet	Centimeters	30.5
Centimeters	Feet	0.03
Yards	Meters	0.9
Meters	Yards	1.1
Sq. Inches	Sq. Centimeters	6.45
Sq. Centimeters	Sq. Inches	0.16
Sq. Feet	Sq. Meters	0.09
Sq. Meters	Sq. Feet	10.8
Sq. Yards	Sq. Meters	0.8
Sq. Meters	Sq. Yards	1.2
Pounds	Kilograms	0.45
Kilograms	Pounds	2.2
Ounces	Grams	28.4
Grams	Ounces	0.04

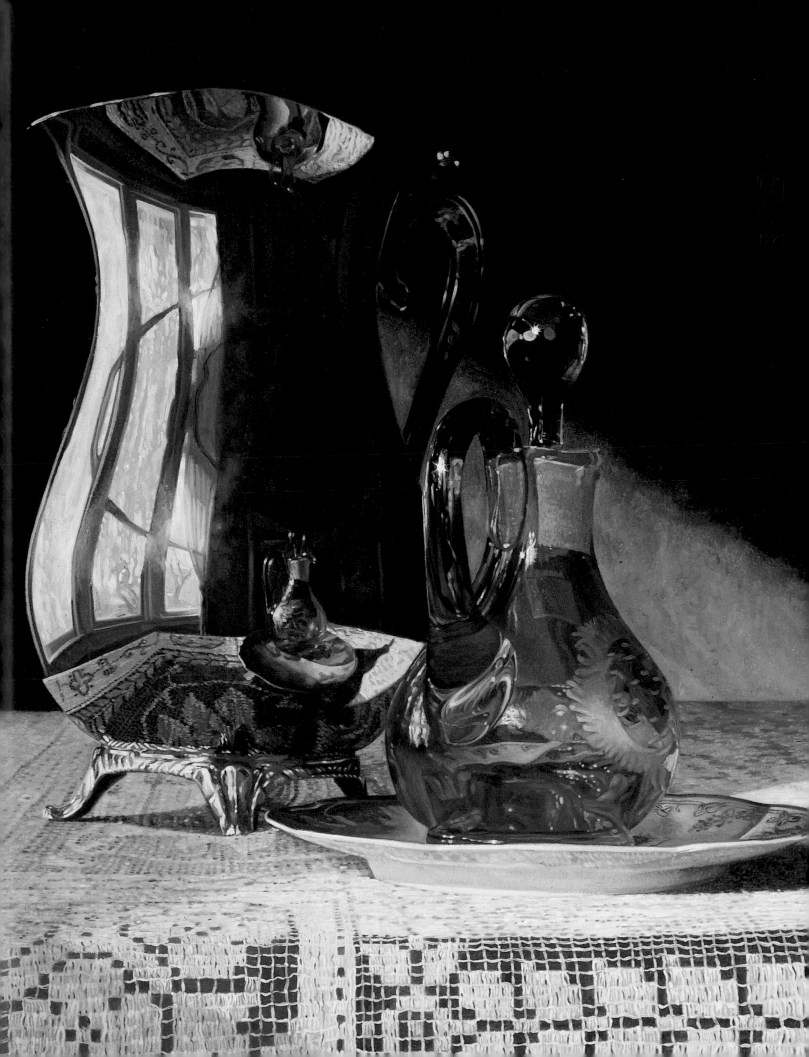

WILLOWS
Acrylic on panel
20" × 24" (51cm × 61cm)
Collection of Leslie Striebinger

ABOUT THE AUTHOR

Mark Christopher Weber was born in 1949 and raised in the Midwest. From his earliest years he was a compulsive sketcher, cartooner and modeler of clay. When, in the second year of college, he finally realized he must do art whatever else may come, he plunged into it with joy and abandonment. He studied painting under Donald Roller Wilson at the University of Arkansas and graduated in 1972 with a bachelor of arts degree. He has, as he likes to say, done a first-class job of being a starving artist. Along the way he married Randi Zeinfeld, a first-class woman, and added at intervals some wonderful and unique kids: Shay, Brody, Zephra, Donovan and Sydney. In the process he realized he needed to be the best family man he could manage and by the grace of God has made reasonable progress in that direction.

Though he focuses most of his effort on landscapes, he has an equally strong affinity for still-life and figure painting. The lion's share of his landscape paintings reflects his love of the American Southwest. His awards include *The Artist's Magazine* 1999 First Prize in Animal Art and 2000 Portrait Honorable Mention, Arts for the Parks 1999 Grand Canyon National Park Association Purchase Award and 2000 Yellowstone National Park Purchase Award, and the 1999 Santa Fe Art Classic Best of Show. His paintings are featured in *The Majesty of the Grand Canyon: 150 Years in Art* and *Art From the Parks*.

He has lived and worked in Kansas City, Missouri, since 1973.

ACKNOWLEDGMENTS

Does anyone ever read these? I know I don't, ungrateful wretch that I am. So I'm probably just talking to myself and the folks that were a huge help in enabling me to distill, illustrate and whip into shape all this loose material floating around in my brain. To Rachel Wolf for finding merit in my ideas and getting me started. What a sweetie. To Jamie Markle, who, in the process of helping me organize all this material and actually make a book out of it, with patience and knowledge answered scores of my novice questions. You and your staff changed this from what seemed a nearly impossible mission into an orderly and eminently doable venture. And while I'm speaking about patience, let's give a big *Hurrah*! to my wife, Randi, who kept everything in the family and household going while I dashed toward deadlines. You helped in countless practical ways so I could focus on the writing, photography and painting; much thanks! And thanks to my son Donovan, who was a good sport about delivering and picking up film, helping with photography and several et ceteras. My daughter Sydney also lent a hand, even two on occasion, with the photography lighting. Zephra, your enthusiasm and feedback added fun to the project. Shay and Brody, thanks for the encouragement and support. And let's not forget the good folks at Keith Coldsnow Artists Materials on Westport Road in Kansas City, who deserve a hearty cheer for loaning me all the brushes and other supplies I used for the nonpainting photography. They didn't scowl even once (at least not in my presence) about reshelving and re-inventorying the hundred or so items I borrowed and returned.

Even if nobody but us knows, I greatly appreciate each of you for the essential part you played in bringing this book from a few scribbled lines and hazy ideas to the work of art it is. If it turns out to be as instructive to the readers as it has been to me, then all our effort was well spent.

TABLE OF CONTENTS

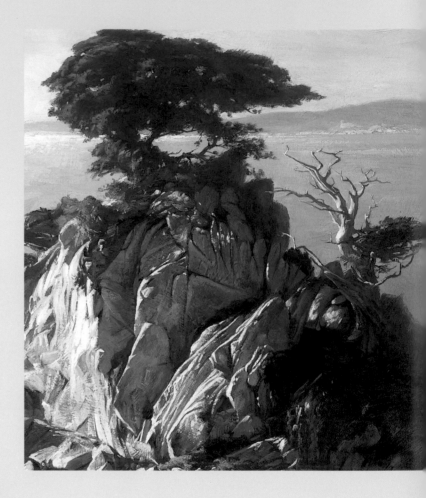

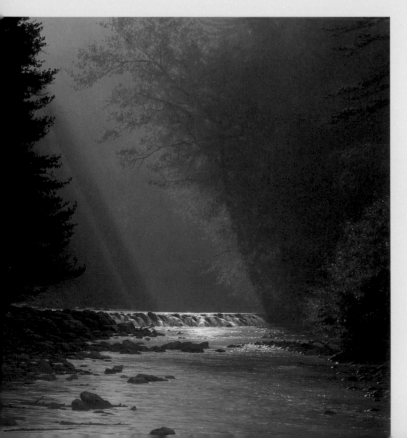

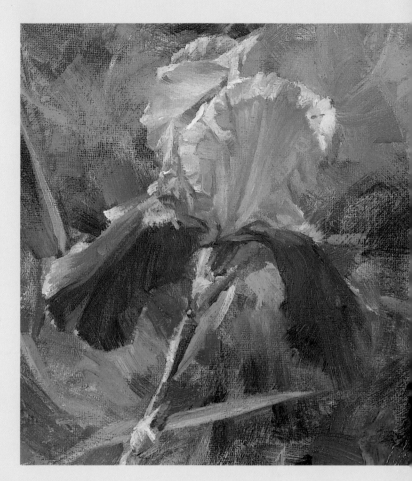

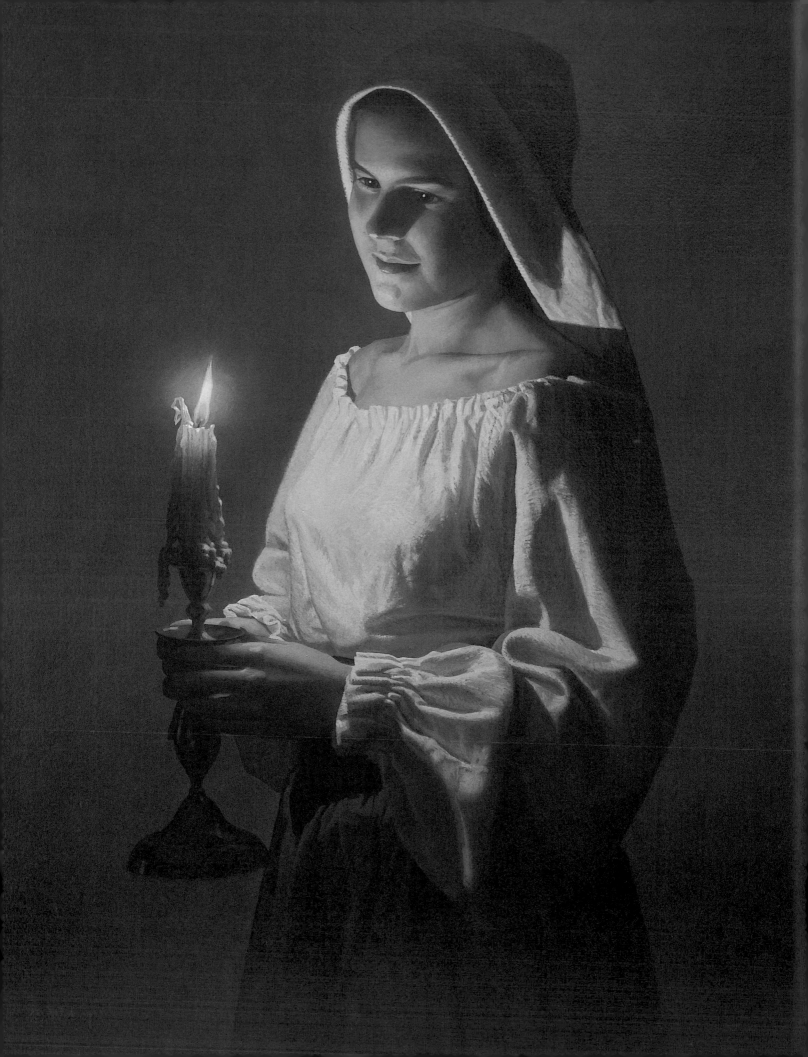

INTRODUCTION

It's an experience I've often had, and perhaps you've had as well: When studying any of a host of instructional oil painting books, I usually find myself asking, "All right, but just how, exactly, did you get the paint to do that?"

Exactly how is what you'll get here: how to clean and shape your brushes for maximum control, how to pick up paint for specific types of strokes, and how to manipulate your brushes to get just the stroke you want, when and where you want it; in short, how to use your brushes to make that rascally oil paint do your bidding.

While I may dabble a bit here and there in some of the other technical aspects of oil painting, don't expect to learn everything in this book. No, siree. It's a brushwork full-court press and nothing but, with the exception of a closing section about painting realistic light effects.

Once I've led you through this simple systematic approach, you'll discover it's much easier to take on other painting challenges. And fortunately, there are a multitude of resources to turn to for answers to all those questions that we oil painters routinely encounter.

Since it would likely require a dictionary-size volume to cover every conceivable brushstroke and its uses, I've kept the book focused on fundamentals. The material here will enable you, through practice and exploration, to expand your brush vocabulary to whatever suits you.

Let this book serve as a set of reliable yet flexible guidelines that will yield consistent, high-quality results. Please don't mistake it for an effort to dictate my own immutable art code. I frequently come across admonitions in art books demanding that the reader absolutely never do something or other; to which I often respond, "Gee, I do that all the time—and with good results." Having a fair knowledge of the variations that centuries of artists have devised, I'm confident that just about everything in this book can in some applications be ignored, done backwards or stood on its head and still create marvelous paintings. Use the information here as a secure base from which to explore. With focused practice and experimentation, you'll be amazed at what you can discover.

There is that troublesome word again: *Practice*. For good or ill, it is as necessary an ingredient to the learning process as water is to growing a plant. Without practice, the information I'm passing on will lodge around your first level of recognition and have little effect on your painting ability. So get on the stick and practice! Through it, my ideas will become your skills. The more you practice, the clearer will be your understanding and the easier you'll find it to have the kind of command over paint you desire.

Although I do provide demonstrations and sample paintings to show how I use various strokes, it's not my intention to insist on using specific brushwork in each and every situation. That, of course, creates a dilemma. How do you know what kind of brushwork to use in which circumstances? The plain fact is that not only is there more than one method to arrive at any specific visual effect, there are so many ways that it would be a hopeless task for me to even begin to describe them. What kind of stroke goes where? In combination with what other brushwork? Well, that depends… and depends… and… Ultimately it depends on the impact you want your work to have on the viewer and the ways you most enjoy handling paint. Not knowing you, I can't address those issues, so I must be content to hand you the raw materials and let you plunge into discovering the applications that best suit your purposes. That's where some of the real fun and satisfaction are to be found.

After all, the endless variations of brushwork techniques that artists create are in part what makes each person's work fingerprint unique. Those quirky gray lumps between our ears devise an amazing variety of ways to use a medium that appears hopelessly narrow: blobs of colored paste smeared around by hair-tipped sticks. The magic, my friend, is not in the medium but in your brain and spirit. My goal is to increase your skill so that you can express the wonders you see, think and are.

Allow me to close with a rare "never do" since you're unlikely ever to get good results from ignoring it. The first rule of successful oil painting: Never put your palette on a chair! (Don't ask how I know this.)

CANDLE LIGHT REVERIE
Oil on panel
20" × 16" (51cm × 41cm)
Private collection

Preparation

Brushes, solvents, mediums, palettes and surfaces all have their strengths and weaknesses. Understanding their optimum uses and avoiding pushing them beyond their limits is essential for producing durable quality oil paintings. Beyond art supplies, studying the brushwork of other painters to discover the expressive possibilities inherent in oils will greatly expand your artistic horizons.

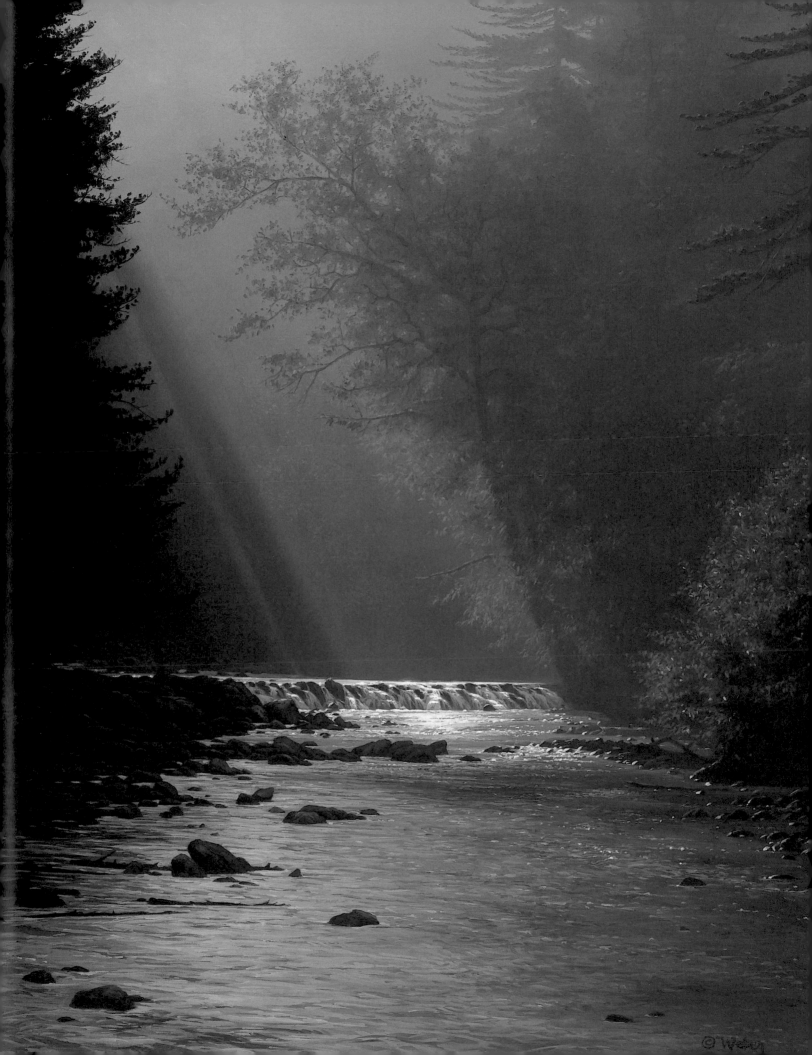

Think Before You Paint

Brushwork is a tool that can powerfully enhance the overall effect and meaning your paintings convey. Whenever possible, before laying down paint, think about how best to use strokes to achieve your end.

What are the possibilities? Studying a broad range of oils by master painters is the most effective way to discover how the huge variety of stroke techniques can aid in conveying a message. At one extreme, smooth paint application without visible brush marks tends to give a restrained and reflective appearance. On the other end of the spectrum, thick strokes furrowed from large bristles and colliding in massive globs create contrast in texture, which catches light, creates shadows and as a result draws the eye just as contrast in color does. And when paint is clumping, dripping and splotting about the canvas, it tends to convey more movement, energy and emotion.

As an example of how brushwork affects the impact of paintings, imagine Vincent van Gogh and Jan Vermeer switching brushstroke techniques while keeping all other elements of their work the same. Vermeer's transcendent peace and order would explode into a jittery, apoplectic mass. And van Gogh's pulsing, dynamic views would shrivel into nondescript renditions afflicted with chronic fatigue syndrome. Using vastly different methods, these two artists expertly crafted every element of their work to create unique and powerful results.

And that is only the beginning of what can be achieved through brushwork. Some types give an impression of breezy spontaneity and competence. Others contribute to a heavy, brooding mood or add to a sense of disjointedness. By some methods, crisp clarity can be produced. Strokes flowing in certain directions can generate a sense of movement. Other patterns can create an impression of stability or even stagnation. There's not a right or wrong type of brushwork—just brushwork that advances your purpose.

Also recognize that brushwork is only one of many elements that shape a painting. Everything from a painting's size, to the colors used, to whether it's vertical, horizontal or round, to subject matter, viewing perspective, composition and so on, all contribute to the impact a piece of work has on its viewers. And all components of a painting interact, so the more skillfully your strokes work together with and accentuate other facets, the more powerful will be the end result.

With each painting, get as clear an idea in your mind as possible of the result you desire, then think through the most effective way to use your materials, tools and skills toward that goal.

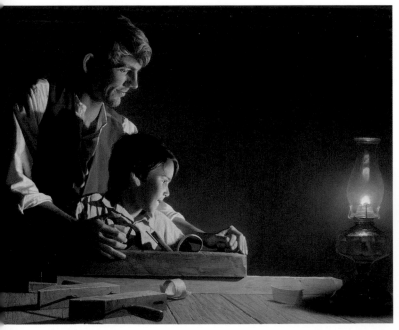

GUIDING HANDS
Oil on panel
20" × 28" (51cm × 71cm)
Collection of the artist

Detail of *Guiding Hands*
I carefully rendered this painting with smooth brushwork to help create a quiet, peaceful mood.

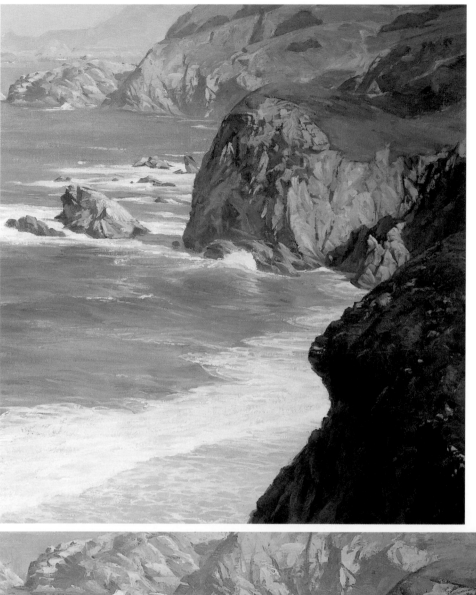

COASTAL COLORS
Oil on canvas
32" × 28" (81cm × 71cm)
Collection of the artist

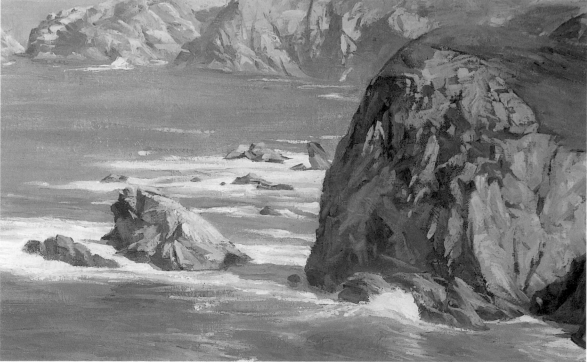

Detail of *Coastal Colors*
I used heavy, plodding brushstrokes to lend the rocks a bit of solidity and create some rough texture.

Paints

TRADITIONAL OIL PAINTS

Use a simple selection of good quality pigments that allow you to mix every color you need. They should be thick enough to cover well (with the exception of inherently transparent colors) and fluid enough to blend easily with a brush. Quality paints are of an even consistency. In inferior paints, the oil frequently separates in the tube from the pigment, creating pockets of oil interspersed with chunks of pigment. You want your pigments to be as permanent and lightfast as possible so the colors don't fade or change hue through normal exposure to light.

WATER-SOLUBLE OILS

After years of trying to work around the health hazards of traditional oil painting solvents, I've switched to painting primarily with water-soluble oils. As a result, I've learned a fair amount about working with this new breed of paint and will include that information in relevant sections of the book.

Water-solubles are oil paints that possess all the body, blending, drying, color and handling properties of traditional oils. However, their vehicle, usually linseed oil, has been chemically altered to enable it to dissolve in water. They don't handle at all like watercolors.

When thinned with water, the paint becomes somewhat milky in appearance, but this disappears when the water evaporates. And once the water is gone, the paint still handles for the most part like any other oil paint. I say "for the most part"

since some brands tend to become a bit sticky once the added water has evaporated. The best brands are not affected by this, an important feature to look for.

As with other oils, a wide disparity exists between the quality and effectiveness of the different brands even though only a handful of manufacturers makes water-solubles. If at all possible, try samples of a brand first. Some lines are superb, while others are so difficult to handle they could be confused with glue. I much prefer Holbein's Duo Aqua Oil.

With quality water-solubles, you can create surprisingly effective washes. This can be helpful in the early wash-in stages if you use that method, and you avoid being assaulted by clouds of turpentine fumes.

Traditional Oil Paints
Traditional oil paints are available in a multitude of colors and can be used with a variety of solvents, oils, varnishes, wax and driers.

Water-Soluble Oil Paints, Oils and Mediums
With water-soluble oil paints, you have the benefits of traditional oils without the harmful vapors from the solvents. Cleanup is an easy task accomplished with just soap and water. Lightfastness, opacity, texture and the variety of color are comparable to their traditional cousins.

Solvents and Mediums

SOLVENTS

Turpentine and mineral spirits are the most widely used solvents for oil paint. These, along with a few other petroleum distillate products, can be used in oil painting mediums and for cleaning brushes and palettes. You need to handle these with care since they are flammable and produce toxic fumes. Because frequent long-term overexposure to these fumes can damage your kidneys, liver and brain, it's essential to adequately ventilate your work area.

There are some odorless solvents on the market, primarily odorless turpentine. In these the scent has been removed, not the toxic fumes themselves. So treat these with as much care as the standard solvents.

Keep in mind that all of these solvents can pass through your skin into your bloodstream and affect your internal organs. Avoid getting these on your hands and arms.

In recent years a few less-toxic solvents have been developed. In my experience they are excellent for cleaning brushes and even superior to turpentine and mineral spirits in removing dried paint from surfaces. They are, however, not as easy to use in painting mediums since they tend to noticeably slow the paint's drying time. Though they're less toxic, it's still wise to use a good ventilation system to eliminate their fumes.

In addition there are at least a couple of truly nontoxic solvents. Again, they are good for cleaning, but I haven't had much luck employing them in mediums, which limits their usefulness.

Should you choose to go the water-soluble oils route, you can simply bypass all the above products and turn on the tap for your solvent.

MEDIUMS

Oil painting mediums can be as simple as solvent alone or increase in complexity to the most exotic imaginable concoctions of oils, solvents, driers, varnishes, wax and other ingredients. In fact, so much information is available that I strongly suggest you get your hands on one or more books that treat the subject in depth to get a solid understanding.

Beyond that, I have only a few thoughts. The oil used in and with oil paints, usually linseed oil or a derivative, sometimes safflower, poppyseed or even walnut oil, is what binds the pigments to the painting surface. It dries by oxidation, not evaporation. Each succeeding layer of wet paint applied over dry paint must have a higher proportion of oil to successfully bind. Otherwise the top layers will be prone to crack and peel. This is the tried-and-true "fat over lean" rule that's proved reliable for hundreds of years.

I do recommend that you avoid using too high a percentage of varnish in mediums since it is susceptible to yellowing and cracking. Also, overreliance on straight solvent to thin oils disperses the binder oil over too great an area, resulting in a paint film that will flake off.

As for water-soluble oils, some of the large art supply manufacturers produce linseed and stand oils that are as water-soluble as the paints. I've even come across a water-soluble medium with petroleum distillates (which seems to me a remarkably self-defeating product).

MY PALETTE

I use Holbein Duo Aqua Oils for most of my paintings. I prefer water-soluble oils because they clean up easily and I do not have to worry about toxic solvents.

Base Palette

Burnt Sienna
Cream (Naples Yellow in other brands)
Light Yellow (Cadmium Yellow Light Hue)
Madder
Marine Blue (Phthalo Blue)
Payne's Grey
Raw Umber
Terre Verte
Titanium White
Ultramarine Blue
Yellow Ochre

Accessory Palette

Burnt Umber
Cobalt Blue
Green
Lemon
Mars Black
Navy Blue (Prussian Blue)
Red
Yellow (Cadmium Yellow Medium Hue)

Mixing and Cleaning

PALETTE

Palettes come in a variety of shapes, sizes, styles, materials and colors. Disposable palettes are made of various materials. You can find handheld palettes made of wood, plastic, glass (a bit on the heavy side), metal, laminated plastic and probably several other materials. A good handheld palette should have adequate space for your initial squeezes of color and the amount of mixing you like to do, should not be too heavy, should balance comfortably on your arm, and should allow your palette hand enough freedom to hold brushes, a painting stick and/or rag. Many palettes start out white or neutral toned so that they don't interfere with the artist's perception of the colors being mixed.

Avoid a palette that is too absorbent since it will suck the oil out of the paint you're working with.

Palettes for water-soluble oils need to be made of waterproof material because wood palettes, even if sealed with polyurethane varnish, will be ruined by the water used to thin paints.

Palettes you place on a painting table can be larger of course and need not be balanced. It all depends on what is most comfortable and efficient for your mode of painting. Fortunately, most palettes are cheap and even easy to make if you can't find just what you want in a store. My studio palette is a narrow benchlike affair fastened to the base of my easel. I made my own location-painting palette of laminated plastic glued to a thin hardwood plywood, cut and sanded to fit my travel easel and balanced for comfort.

PALETTE KNIVES

A palette knife is a handy little tool used for mixing paint, scraping paint from the palette, even cleaning paint from brushes, along with a number of other minor tasks. Knives can also be used for painting, but that falls outside the scope of this book.

They come in a large number of shapes and several sizes. Choose a knife that is easy to use, nonrusting and reasonably flexible. Make sure the blade's shaft is firmly set in the handle and that the ferrule at the base of the handle is solidly attached, as well.

RAGS

Those humble wads of cloth we smear, dump on, cast aside and generally abuse are our most important tools for maximizing brush control. Rags can also be used as instruments to apply paint. They must be sturdy, lint-free and at least fairly absorbent. Different types of fabric are acceptable, even tough paper towels, just so long as they don't shed, tear apart or release fibers and particles, which are maddening to remove once they end up in your paint. I prefer cotton rags, especially flannel, since they are great at sucking paint from my brushes and don't attract lint.

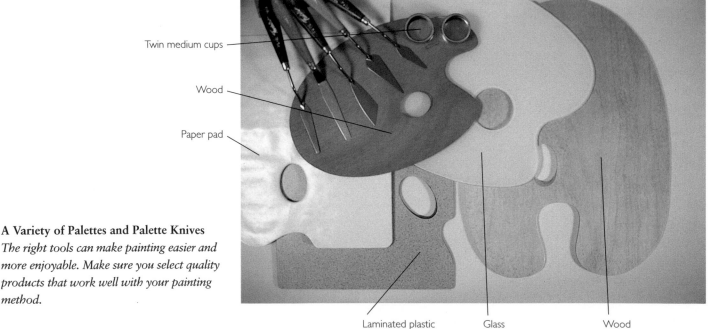

Twin medium cups
Wood
Paper pad
Laminated plastic
Glass
Wood

A Variety of Palettes and Palette Knives
The right tools can make painting easier and more enjoyable. Make sure you select quality products that work well with your painting method.

Painting Surfaces

As with mediums, you would be wise to study a good art materials handbook to discover the large number of choices available in oil supports and surfaces. They run the gamut from fabrics of various kinds, cotton duck and linen being the most frequently used; to wood products, such as hardboard, plywood and paper; to clayboards, Mylar and even metals and glass—anything that will stand still long enough to get painted. Several priming options exist, as well as a large range of textures.

The type of surface used is one of those factors that subtly affects the impact of a painting.

Although the subject is too broad to thoroughly cover here, I have a few helpful thoughts. Oils painted directly onto unsized or unprimed fabric or paper will cause the surface to disintegrate over time.

Also, while you'll want to experiment to discover what degree of absorbency works best for you, it's wise to steer clear of surfaces that are either too absorbent or not absorbent enough. Those too absorbent suck up so much of the paint's oil that the pigment cannot bond to the surface. When the paint dries, the color powders and flakes. On the other hand, a nonabsorbent surface will not be penetrated by enough oil and the paint is at risk of peeling when dry.

Special attention is needed when painting on extremely coarse or extremely slick surfaces. I don't mean to say you can't do this. It's just that with a very coarse surface, you must be prepared to put extra effort into working the paint into the low points of the weave to cover all the white of the ground. And with very slick surfaces, even

when they are reasonably absorbent, the paint tends to skid around and not stay where you put it.

Stretched canvas and linen expand and contract with changes in humidity. The fabric can take this continual stretching and shrinking, but the less flexible paint film can suffer significant cracking over the years. To eliminate the expansion/contraction bugaboo but keep the fun of painting on canvas, I usually work on homemade canvas panels. I prefer my own to the store-bought kind. I glue canvas to luan underlayment, a lighter, more stable type of quarter-inch plywood. To bond acrylic-primed canvas to the plywood, I use acrylic gloss medium, and for raw linen, I employ rabbitskin glue and apply a white oil ground.

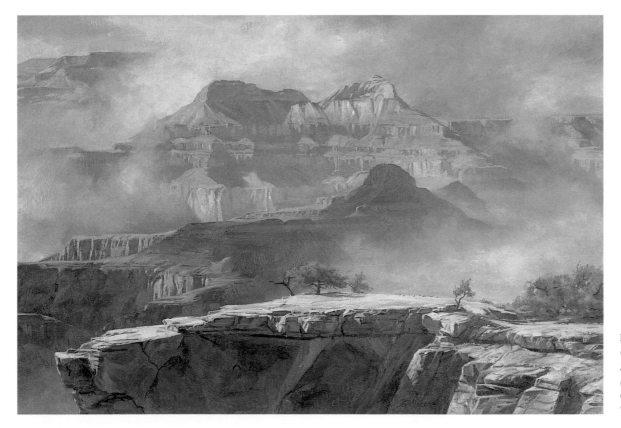

LAYER ON LAYER
Oil on canvas
20" × 30"
(51cm × 76cm)
Collection of Steve and
Trish Fortuna

Brush Basics

Familiarize yourself with the brush terminology in the illustration *Anatomy of a Brush*. You'll save yourself a lot of turning back to this page once I start taking you through the hows and wherefores in following chapters.

Brushes vary in size and design. Finding the correct brush for the exact stroke you want is imperative. Study the photographs of each brush to learn why each is different and what each brush has the potential to do.

For easy reference, each brush type has an accompanying icon. Each section has icons at its head so that you can tell at a glance what type of brushes the instruction applies to. The all-brush icon (left) indicates that the instruction is appropriate for all brush types.

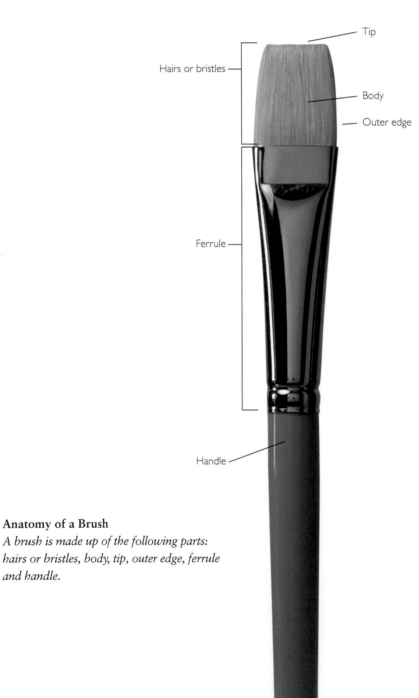

Anatomy of a Brush
A brush is made up of the following parts: hairs or bristles, body, tip, outer edge, ferrule and handle.

Brights
Brights and flats share the same square-tipped shape, but the bright, with its shorter hair, is stiffer and stronger than a flat of the same size. Brights, especially those made of bristle, are superior for scrubbing and working paint into surface texture, and their strength makes them the obvious choice for carrying large loads of thick, heavy paint. Why wear out your finer brushes on scrubbing? Leave that task for the brights.

Rounds
The sharply pointed tips of rounds make them excellent for rendering careful details, while at the same time their relatively short hairs give them the strength to manipulate fairly thick paint. Limited in the amount of fluid paint they can hold, they are less suitable than script liners for painting long lines.

Flats

Because their bristles are longer than those of brights, flats are more flexible and come to a finer point, making them easier to control for smoother blending and details.

For those of you familiar with calligraphic pens, you could think of flats and brights as being like a C pen point. They are capable of making strokes that change from wide to thin just as the C nibs do.

Filberts

The flat bodies and nicely rounded tips of filberts create distinctive oval-ended marks. Since they come in varying bristle lengths, remember that shorter means stiffer and longer means more flex. Good filberts are smoothly and evenly rounded.

Worn Brushes

As they wear, some brushes develop new characteristics that are handy for different effects. I have some small synthetic brights that have morphed into short-haired filberts and are great for sketching in the initial lines of a painting. Others of my brights have been chewed down to thin, raggedy instruments that I use for foliage. Some brushes even improve with age, so don't judge a brush by how it looks but by what it can do for you.

Script Liners or Riggers

A strangely long, almost whiplike cousin of the round, the script liner, or rigger, is ideal for rendering very fine, long lines, such as branches, telephone wires and ship rigging. They are also good for painting small dots. I don't mean to gossip about character flaws, but they have no backbone whatsoever and are not up to the task of moving even medium-consistency paint but can manage only extremely fluid pigment.

Fan Brushes

Blending paint that's already been applied to a surface is the fan brush's primary function. The sable and soft synthetic fans don't have enough strength to do more than that, but the bristle fans can also be used for quickly creating streaky and splotchy effects.

House Brushes

House brushes are handy for scrubbing or blocking in large areas and, if skillfully used, can create interesting textures and mottled areas. A few are sold in art stores and far more are available in hardware stores. As with art brushes, house painting brushes are made of both natural and synthetic bristle.

Choosing a Brush

NATURAL VS. SYNTHETIC

Brush hairs are made of two basic kinds of materials: synthetic fibers and natural hairs from a variety of mammals. Until recent years natural-hair brushes were far superior to synthetic fibers in spring, control and holding a shape. Now, however, a number of synthetic brushes are nearly as good as sable and certainly more durable and less pricy. Other synthetics are very close to fine hog-bristle brushes. I expect over the next few years that the fiber scientists will equal and surpass the best natural-hair products.

Natural—The combination of softness, spring and control of red sable makes it the premiere choice for soft-haired brushes, but camel, squirrel, badger and mongoose hair are also used. Anyone for skunk hair? All of these have somewhat different working characteristics. Hog hair is used to make bristle brushes.

All the natural hairs absorb water, which reduces their strength and spring to varying degrees. Some are reduced to wet-noodle uselessness. For this reason they become more difficult to use with water-soluble oils if you thin with too much water or rinse as you paint. Bristles in particular swell up and become unmanageable mops.

Synthetic—Modern technology has brought us so far beyond our cave-painting ancestors that we can now create our artistic wonders with polyester- and nylon-tipped sticks! Synthetic fibers can be used to fashion incredibly soft brushes or rough-and-tumble bristles.

The synthetics are nonabsorbent, so their spring and shape are little affected by water when thinning water-soluble oils. The hair of nearly all synthetic brushes, especially the softer varieties, will sooner or later begin to curl outward. This renders the brush useless for fine control unless you trim off the offending hairs.

Since I work primarily with water-solubles, I almost exclusively use synthetic brushes. The Princeton 6300 series is an exceptional brush, having the strength and durability of a good bristle and at the same time coming to a point as fine as many a sable. They handle like a dream. I use several brands of synthetic sables, like Winsor & Newton Galerias, when I need a softer touch or am doing fine detail.

BRUSH WEAR AND TEAR

All brushes wear down, but good ones keep their shape and a degree of usefulness even until you wear them down to the metal.

Synthetic vs. Natural

A selection of synthetic-fiber brushes are on the left and natural-hair brushes are on the right.

BRISTLES VS. SABLES

In this section and throughout the remainder of the book, when I refer to bristles and soft-haired brushes, I mean to include both natural and synthetic fibers. If I need to distinguish between natural and synthetic fibers, I'll say so.

Bristles, natural and synthetic alike, have certain properties in common. And the soft brushes, natural and synthetic, share a set of strengths and weaknesses.

Bristle brushes are made of thicker, stronger hairs than the soft brushes. Their resulting strokes leave larger but fewer grooves in the paint, creating more noticeable brushwork. Sables and soft-haired brushes are crafted from thinner, more flexible fibers that form more and shallower grooves in the paint, achieving smoother and less obvious brushwork. Their thinner hairs are more easily damaged by rough use. Most soft watercolor wash brushes simply do not have the strength to deal with the body of oils.

It's important to take into account these qualities in approaching a painting. When working on a smooth surface, stiff bristles slice through the wet paint to the dry surface below. If you want smooth, even coverage instead of that scratchy appearance, a soft-haired brush is the obvious choice.

On the other hand, rough painting surfaces eat soft-haired brushes. The hard peaks of a coarse-weave canvas or rough-textured gesso will nick into the sides of soft hairs as they are dragged across if you paint with even moderate vigor. Before you know it, you've worn an eighth of an inch off a perfectly fine sable. Bristles will stand up to this beating far better.

LONG VS. SHORT HANDLES

Short-handled brushes are primarily used for close-up careful work that requires a lot of control. If you like to get right on top of your work, you don't want to have a long handle waggling around in front of your nose. On the other hand, long handles make it possible to get farther back from your work for a better overall view while you paint, and you can work without having your hand smack in the middle of what you're looking at. You can also more easily make longer sweeping strokes with the long handles.

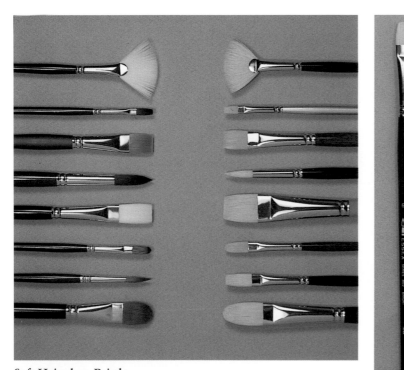

Soft Haired vs. Bristle
A selection of soft-haired brushes are on the left and bristles are on the right.

Long vs. Short
This illustration contrasts long- and short-handled brushes.

Buying Quality Brushes

It is so thoroughly satisfying to be painting away with a brush that empowers you to deftly manipulate the paint. But a bad brush and an upset stomach go hand in hand. How can you tell a good brush from a bad one before you've invested wads of money?

HANDLES AND FERRULES

Pick brushes that have straight, unwarped handles. The ferrule should be mounted tightly on the handle and in line with it, not off at an angle.

How many crimps secure the ferrule to the handle? One crimp is a tip-off that you're probably looking at a sorry piece of merchandise. Don't settle for less than two, with the possible exception of some plastic-handled brushes.

HAIRS

The better the brush, the more smoothly and uniformly the hairs taper to a fine-pointed tip. Hog hairs have flagged ends; that is, instead of coming to a single point, they have two or three points, which increases the amount of paint they can hold. Makers of good brushes take extraordinary care in lining up and arranging the hairs to achieve the right tip shape and maximum control for each brush. Manufacturers of cheap bristles bundle the hairs together in more or less the right arrangement, then cut the hairs to get the desired tip shape. In the cutting process, they eliminate the flagged ends and deprive the artist of one of the advantages of a fine bristle. When examining a natural-bristle brush, stroke the tip. If tiny fragments fly off, you'll know the brush's tip has been trimmed. Since synthetic bristles do not

have flagged ends and all synthetics are cut to shape, don't worry if you generate a cloud of trimmings when you stroke their tips.

WATERCOLOR BRUSHES

When considering watercolor brushes for use in oil painting, read the label on the brush display or advertisement. Most of those designated as only watercolor brushes have their hairs cemented together at the base with a glue that can be damaged and dissolved by oil solvents. The ones you're looking for are labeled "watercolor and oil" brushes. These employ the necessary solvent-resistant glue.

If you clean your brushes with water or work with water-soluble oils and discover the handle enamel cracking soon after buying them, you've found a weakness. Once

the enamel begins to split, the ferrule will loosen and swivel on the handle or fall off. Too much exposure to water is tough on any wooden-handled brush, but quality brushes should endure a lot before they are affected.

TRIAL AND ERROR

Examining a brush at the store will tell you only so much. The next step is to buy and try one or two of a brand you're interested in to discover how well they handle the paint and how durable they are. Some brands lose their bristles, others lose their shape; and some just plain fall apart.

As for handling properties, gaining experience through working with your brushes is the only way I know to discover which types and brands give you the kind of control you want.

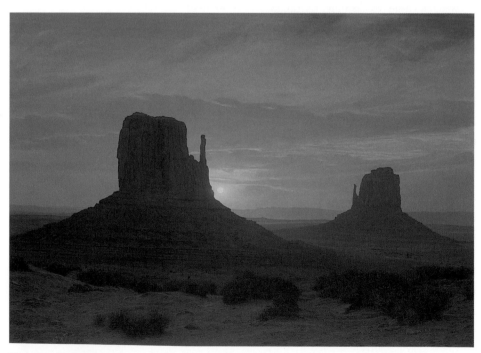

NAVAJO SUNRISE
Oil on panel
20" × 30" (51cm × 76cm)
Private collection

Brush Care

You can kill a wonderful brush overnight through neglect, but with proper use and care, it's possible to keep your brushes useful and happy for quite some time. Whether painting or cleaning, pull your brushes and avoid pushing them. Pushing dramatically increases wear on brush tips and encourages the bristles to flair out from the body. Given enough pushing, the bristles will permanently splay.

Even with proper technique, some hair flair is unavoidable. You can trim errant hairs at their base with a sharp knife, being careful not to slice into inner bristles that are still straight.

BRUSH CLEANING

You probably know by now that if you leave a brush out until the next day's or week's painting, the oil paint dries, cementing the bristles together.

When it comes to cleaning, thoroughness is the key to brush longevity. You clean your brushes and then set them aside to dry, right? But whatever paint is left behind dries rock hard. After several less-than-thorough cleanings, the dried paint builds up at the base of the bristles and in no time robs brushes of their flex and causes the hairs to splay and divide.

To clean with turpentine or petroleum distillates, use a glass container (glass is smoother than metal) to hold the solvent, then swish the brush around. It's OK to lightly drag the brush over the container bottom, but don't mash it down, because that weakens and breaks the bristles. Repeat the procedure until you've gotten out as much paint as you can.

Cleaning with solvent alone rarely removes enough of the paint. You'll need to finish with dish detergent or an artists' brush-cleaning soap. Work on a smooth surface, such as porcelain, glass or plastic. With the brush handle at about a 30-degree

angle, pull (remember, lay off the pushing) while applying gentle downward pressure on the body. Exert enough force to work the soap and water into the base of the bristles but not enough to damage the hairs. When you've dirtied the soapsuds, rinse the brush and pull through a rag to wipe the hairs; start over with clean soap and repeat until the suds are clean. Finally, use your fingers to form the body into its original shape.

For those who want to steer clear of toxic solvent fumes, it's perfectly acceptable to bypass the solvent stage altogether and begin with brush soap or detergent. True, it takes longer, and you can run through the brush soap pretty quickly, but for myself I'd much rather that than run through my health faster than need be.

After washing and shaping, lay the brushes flat to dry or suspend them tip down. If you leave them in a vertical position tip up, the water soaks into the wood of the handle, causing it to swell and eventually split the enamel.

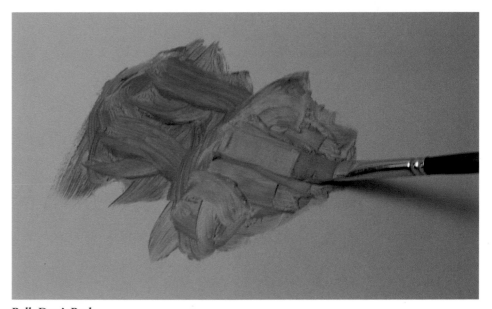

Pull, Don't Push
Pull the brush in line with the bristles to work soap into the base of the hairs. Have the handle at about a 30-degree angle. This is an effective cleaning method that keeps brush wear to a minimum.

2 | How to Mix Paint

Since none of the paint manufacturers seems to want to make tubes of every color we could conceivably use in any particular painting (Daffodils-in-Shadow-on-a-Sunny-Day Yellow), and we couldn't find room on our palettes for all those colors even if they did, we'll just have to buckle down and mix our own from the basic colors provided.

In many applications it also becomes necessary in the midst of mixing colors to alter the paint's consistency, that is, its viscosity. This requires a basic understanding of not only paint consistency but mediums and solvents, as well.

Depending on the painting, I use a palette of about nine to twelve colors. I also keep on hand a few additional colors that I use in certain instances. I work almost exclusively with Holbein Duo Aqua Oils, far and away my favorite among water-soluble oils. They have wonderful body and good color density, and they thin excellently with water without becoming gummy as do nearly all the other brands I'm familiar with. The pigments I most frequently use are Titanium White, Cream (this is actually Naples Yellow, I am mystified by Holbein's tendency to apply interior-designer-type names to some standard artist's colors), Yellow Ochre, Light Yellow, Madder, Burnt Sienna, Raw Umber, Terre Verte, Ultramarine Blue, Marine (Phthalo Blue) and Payne's Grey. Some of these I could mix myself, but I find the tube colors more convenient. For medium I employ Winsor & Newton Artisan Water Mixable Linseed Oil and, of course, water. Brushes, solvents, mediums, palettes and surfaces all have their strengths and weaknesses. Understanding their optimum uses and avoiding pushing them beyond their limits is essential for producing durable quality oil paintings. Beyond art supplies, studying the brushwork of other painters to discover the expressive possibilities inherent in oils will greatly expand your artistic horizons.

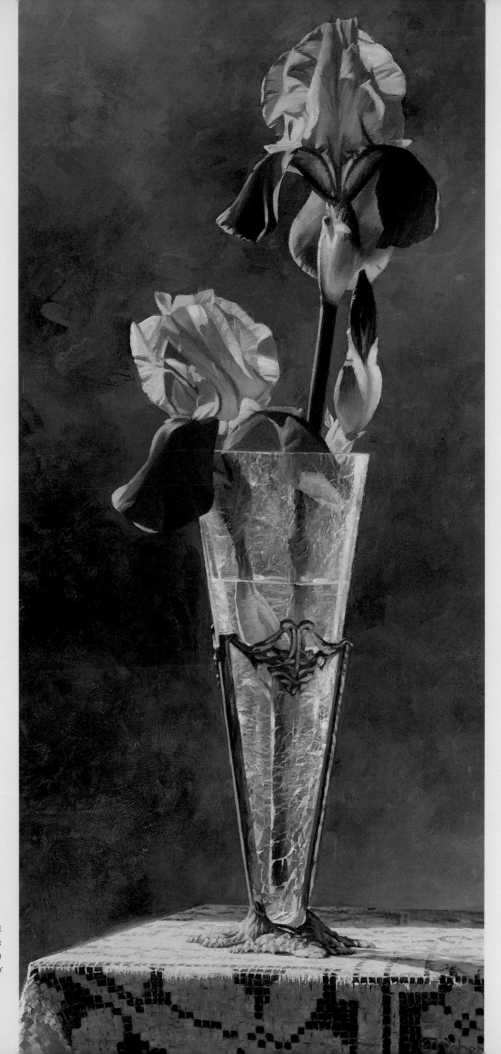

IRISES IN A VASE
Oil on canvas
32" × 18" (81cm × 46cm)
Collection of Doris Grof

Paint Consistency Continuum

The type and character of the brushwork you can do is determined in part by the viscosity, or consistency, of the paint being used. I want to give an overview of the basics of paint consistency, keeping our eyes as always on brushwork.

Anyone who has tried several brands of oils can tell you that the viscosity of tube paint differs noticeably from one manufacturer to another. Some are pretty stiff, while others can be quite fluid. One brand of water-solubles reminds me of gel toothpaste. Even within each line of paints is a range of viscosity from one color to another. Earth colors tend to be thicker and a

bit on the grainy side, while more transparent colors like Rose Madder lean toward greater fluidity.

Think of paint consistency as being a continuum that runs from straight-from-the-tube thick to ink-thin paint. Each degree has its applications as well as its pros and cons.

In order to provide a common reference point to make this matter of paint viscosity more understandable, I've chosen a group of household products that everyone will be familiar with or have access to. That way when I refer to a certain paint consistency by number, say no. 3, you'll be able

to check back to its kitchen equivalent and know just what I mean without me spouting condiments all over the place.

With the exceptions of peanut butter and cooking oil, I'm using all refrigerated items. And I didn't want to raid the grocery store to try umpteen brands of each product, so just think of your average mayo, ketchup or whatever.

We start the continuum with creamy peanut butter and refrigerated margarine, which are very close in consistency to tube paint, and progress all the way through to cooking oil standing in for paint thinned to the max.

Tube paint **Medium viscosity** **Very thin**

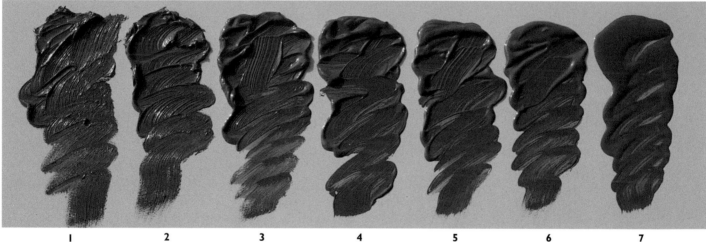

1	2	3	4	5	6	7
Margarine, peanut butter	Sour cream	Mayonnaise	Dijon mustard	Ketchup	Tomato sauce	Cooking oil

Consistency Continuum
These paints have increasing amounts of medium, beginning with straight tube paint at the left. Their kitchen equivalents are listed beneath each consistency.

Thick Consistency

Thick-consistency paint lends itself to wonderful impasto passages that can energize a canvas, and thin-viscosity glazes can create dazzling rich colors and translucent effects. You need to learn the intelligent use of all types of consistency to make the most of your paint and avoid unnecessary trouble spots.

On the left side of the continuum, paint thinned with little or no medium retains more body for thick brushstrokes. This is needed for impasto work. Since the paint is more opaque, it covers well. Being undiluted with additives, it is less likely than thinned paint to experience yellowing and deterioration. The downside is that it is more difficult to apply in a thin, smooth coat.

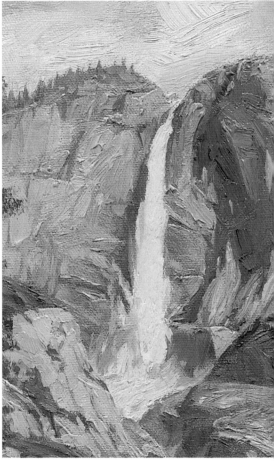

Detail of *Yosemite Falls—Morning*
This detail shows impasto brushstrokes that can be created with thick-consistency paint. Since little or no medium is added, the paint retains more body and is more opaque.

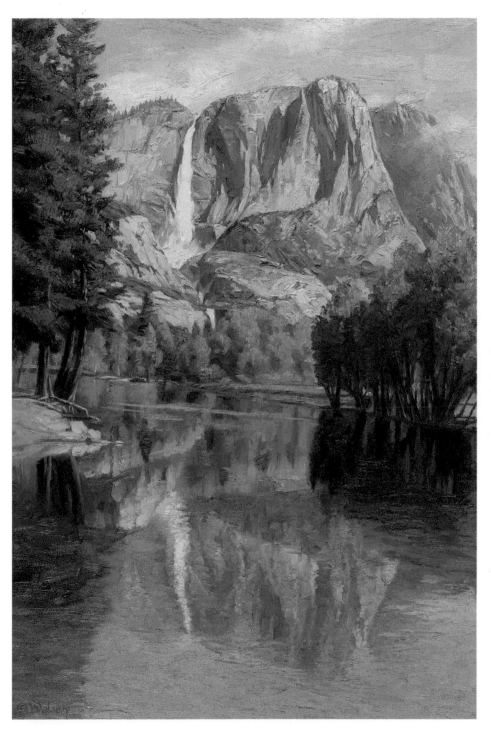

YOSEMITE FALLS—MORNING
Oil on canvas
24" × 18" (61cm × 46cm)
Collection of the artist

Thin Consistency

At the other end of the continuum, larger amounts of medium increase the paint's fluidity, making it easier to apply and blend smoothly. As color is thinned by medium, it becomes more transparent for glazing and scumbling. Thinned paint can also create interesting washes.

But there's another side to this equation.

When oil paint is diluted with medium or solvent, it increasingly takes on characteristics of the thinning agents as their proportions rise. A greater percentage of linseed oil means more yellowing. Higher levels of varnish increase the brittleness of the paint film and add to the yellowing. When a large amount of medium with a high

concentration of oil and varnish is used, the resulting paint film is likely to remain tacky even when dry and behave like a dust magnet. Straight solvent disperses the oil over a wider area, leaving less to bind the pigment to the ground. Some driers cause paint to darken and crack.

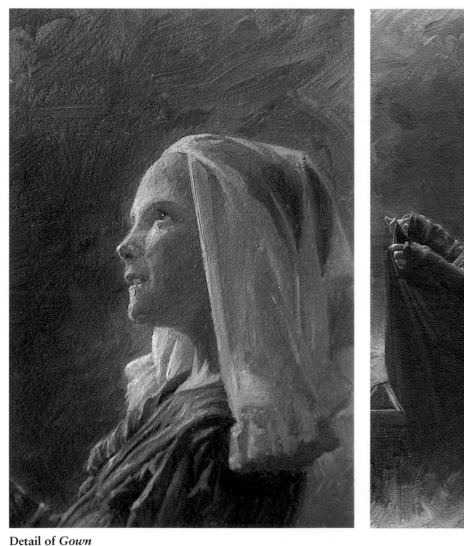

Detail of *Gown*
Adding more medium to the paint increases its fluidity, facilitating washy brushwork, as in this example.

G O W N
Oil on panel
18" × 7" (46cm × 18cm)
Collection of the artist

Mediums and Solvents—Easy Does It

As you can see, you can paint yourself into all sorts of corners by overzealous use of paint modifiers. My general advice is to go easy on the medium and solvent. A surprisingly small amount will go a long way in making tube colors blend and flow more smoothly. You might think that combining equal parts tube paint and medium will result in a mix of medium consistency. Such a mixture will in fact yield a pretty drippy no. 6 or 7 consistency.

BUTTERY PAINT ALERT

Once when I was fixing a peanut butter and jelly sandwich for one of my kids, she asked me to put jelly on the bread first and then spread the peanut butter on top of it. I naively complied with this devious request only to discover that it was nigh on impossible to spread that peanut butter on the jelly. It just would not stick! That is the very dilemma we create for ourselves when we initially apply a deep, fluid layer of buttery paint and try to work into it with paint of greater viscosity. The top stuff just does not want to stick to the bottom layer!

Don't despair, those of you who want to master impasto brushwork! In areas where you want to work wet-into-wet, plan ahead a bit so that you'll be working into paint of manageable consistency. Make your first application of fairly heavy viscosity, no. 1–2, but somewhat thinly applied. Then you can start working your impasto strokes into this base coat and they'll stay where you put them.

One other possibility is to use thinner consistency for your later strokes than the base into which you're painting—thin consistency on top of thick.

Peanut Butter on Jelly
I tried to paint onto a deep layer of no. 3 consistency red paint with no. 1 yellow pigment. The yellow paint slips and slides through the base layer without adhering.

Peanut Butter Is Sticky
The brush picks up more paint than it deposits.

Jelly on Peanut Butter
Use thick-consistency paint fairly thinly applied (you can see the canvas weave through it). Then lay down impasto strokes.

Mixing With a Palette Knife

Palette knives are handy tools for mixing large quantities of pigment and save wear and tear on brushes. They are also a lot easier to clean than brushes if you are concerned about contaminating your tube piles with errant streaks of paint.

If you're a whiz at knowing the proportions of each tube pigment required to mix a new color, you can just squeeze those amounts in the middle of your palette and go at it with your knife. For normal mortals (myself included) who need to figure the proportions as we go along, it probably works better to use the knife tip to pick up paint from tube piles, then mix, adding a bit more of this or that as we see what is needed.

If you need a goodly amount of pigment, you can save time by mixing up a large enough pile of paint for the job rather than repeatedly mixing small amounts of the same color when you run out every minute or two.

When starting out with large amounts of tube paint, it's easy to make a mistake, causing you to mix far more than you need. I'll often mix up a very small amount to make sure I know what I'm doing, then mix the large pile to match.

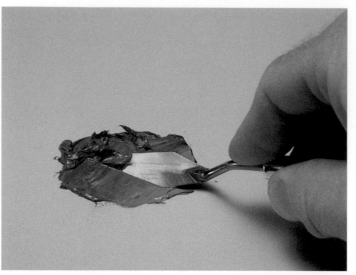

Using the Palette Knife
Trowel the pigments back and forth with a palette knife until they are mixed to the consistency and degree of evenness desired.

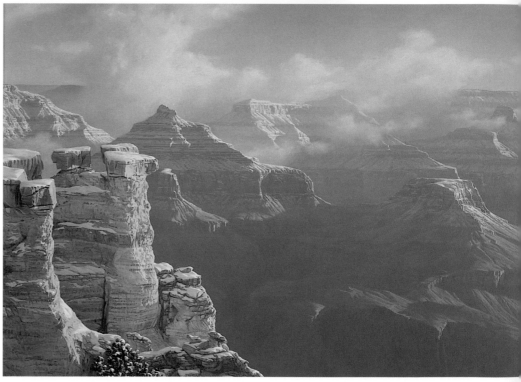

FROSTED CANYON
Oil on panel
20" × 30" (51cm × 76cm)
Collection of Carl Ruggins

Mixing With a Brush

For some folks it's a nuisance shifting from brush to palette knife to mix, then back to brush to apply the paint. And a brush is usually quicker and easier for mixing small piles of color. Mixing colors with brushes requires only a few simple skills.

USE THE TIP

It works best for the most part to mix paint with the tip of your brush. If you get the entire body involved, the paint globs up around the ferrule, doesn't mix thoroughly and is difficult to control when you apply a stroke. Ignore this advice if you're looking for a globby streaked paint application, which can be wonderful in the right place.

Suppose you're in an inspired frenzy (or just plain lazy) and don't want to take the time to wipe your brush before picking up paint from a nice clean tube pile. How do you manage this without contaminating your tube pile with all the wrong colors? Instead of dragging your dirty brush through the center of the pile, use the tip to pull off a bit of pigment from the edge. Yes, you'll probably leave a smear of color on the pile, but it's off to the side and won't interfere when you need a dab of clean pigment.

PULL, DON'T PUSH

Pushing into paint with your brushes creates a lot of unnecessary wear on the tips and splays the hairs. Splayed hairs drastically reduce your control over the paint. Pulling through the paint as you mix reduces brush wear, as well as keeping your brush hairs aligned for better control.

Wrong: Pushing
Pushing on the brush to mix paint splays the bristles out every which way, greatly reducing control and needlessly wearing out the tip.

Right: Pulling
Repeatedly pull through paint to keep the bristles in line for better control and to minimize tip wear.

SIDE-TO-SIDE MIXING MOTION

A side-to-side mixing motion is actually a variant of the pulling motion. But rather than pulling toward yourself, you pull laterally, then, using the other side of the brush, pull back in the opposite direction. The considerations over which method to use are minor. In pulling straight back, you can get by with using less room on your palette, and it's easily done with your finger muscles. The side-to-side motion, while taking up more space, makes it easier to work with larger amounts of pigment, and the motion is generated from the wrist.

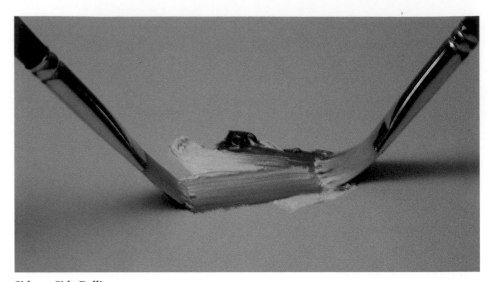

Side-to-Side Pulling
This time-lapse image demonstrates how to pull in one direction, then, using the other side of the brush, pull back in the opposite direction.

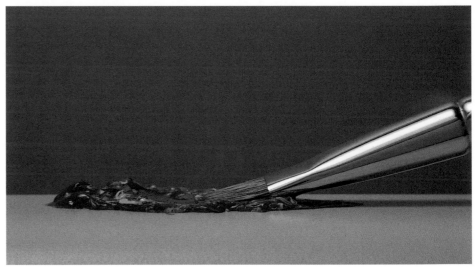

Mixing at Too Shallow an Angle
A 30-degree or steeper brush-to-palette angle is best when mixing paint. Using a very low angle invites the paint to climb up the hairs to the ferrule and create a globby nuisance. That paint buildup at the base of the ferrule has a tendency to land in places you're not intending, especially when applying paint at a shallow angle.

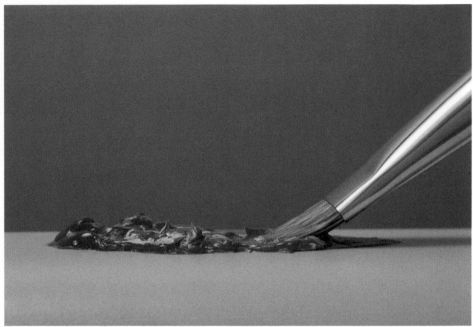

Paint Buildup on the Ferrule
This is the kind of paint buildup you create by mixing at a shallow brush-to-palette angle. The buildup can land on parts of your painting where you don't want it.

The Correct Angle
It's practical to use anywhere from a 30- to 90-degree brush-to-palette angle.

Mixing Variations

I want to cover three mixing variants: complete, incomplete and mixing on the surface.

COMPLETE MIXING OF PIGMENTS AND MEDIUMS

Thoroughly mixing pigments and whatever medium you add yields a uniform color and consistency. When you apply the paint, you won't get any surprise unmixed colors popping up or drips of medium running down your canvas. And if you want to use the same color in different parts of your picture, you can count on it being identical. The recipe to achieve this is simple: Just keep working the pigments and medium back and forth with knife or brush until they are evenly blended.

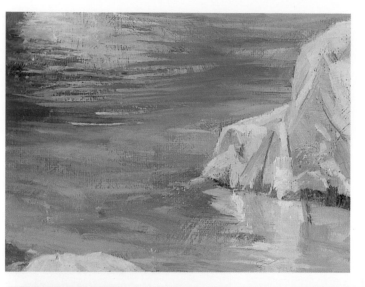

Complete Mixing
The pigments and mediums are thoroughly mixed to an even color and consistency for the dark blue-green of the water in shadow in Big Sur River.

Detail: Color Variety
Even though this painting has a lot of color variety, all the colors have been completely mixed on the palette, then in some instances they've been partially blended with each other.

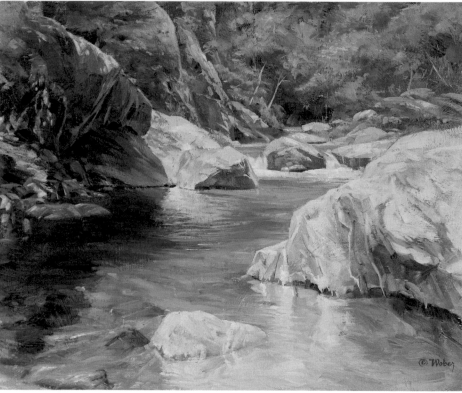

BIG SUR RIVER
Oil on linen
16" × 20" (41cm × 51cm)
Collection of Pete and Carol Bachhuber

INCOMPLETE MIXING OF PIGMENTS WITH EACH OTHER

The advantage to mixing pigments incompletely is that the color on the canvas is broken up by flecks of other hues, which can add a little shimmer and excitement to the paint body. If you want the paint consistency to be thinner than straight from the tube, however, you'll need to mix each color with medium before partially working them together. Otherwise you risk unmixed medium drooling down your painting.

Incompletely Mixed Pigments on the Palette
Pigments that are not thoroughly mixed can cause uneven coloration on the painting surface, adding interest to your subject.

Detail: Incomplete Mixing
Strokes using incomplete pigment mixing are evident in this detail of the lower right corner of Tiger Lilies.

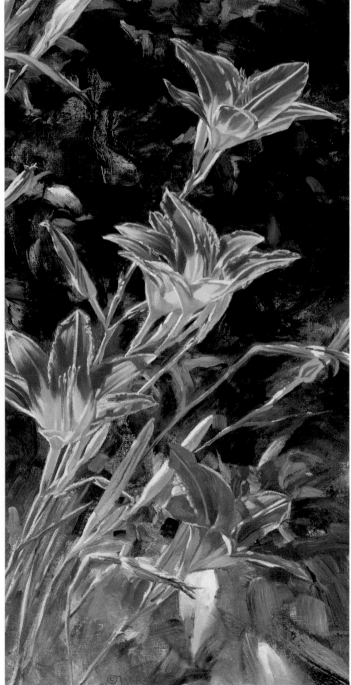

TIGER LILIES
Oil on linen
24" × 12"
(61cm × 30cm)
Collection of Mary Bumgarner

MIXING PIGMENTS ON THE PAINTING SURFACE

You can go straight from tube pile to canvas when you mix pigments on the painting surface. This method requires a good deal of color knowledge and thinking ahead to arrive at the hues you're after while maintaining the drawing and degree of contrast you want, but it can push you into creating works with much more brilliant color and a sense of spontaneity.

Mixing Pigments on the Canvas
Here, I'm mixing straight Madder into straight Titanium White right on the canvas.

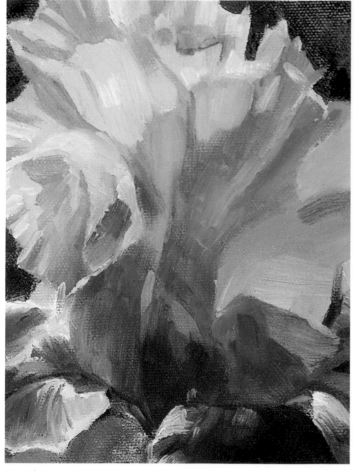

Detail
Close-up of the finished petal of Flaming Iris.

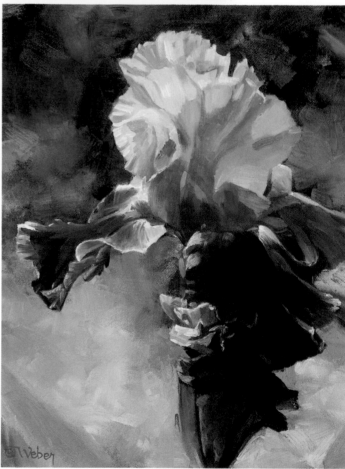

FLAMING IRIS
Oil on canvas
14" × 11" (36cm × 28cm)
Collection of Larry LeMasters

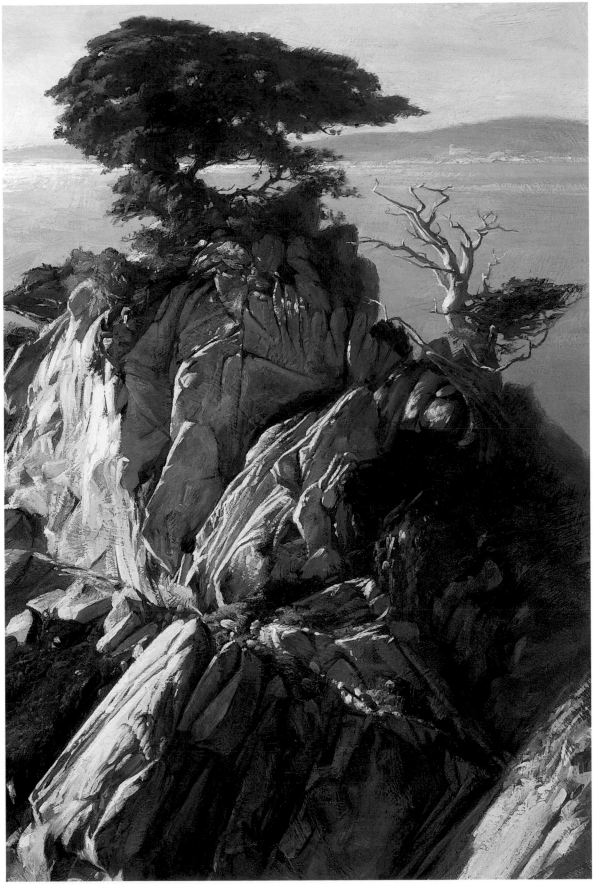

CYPRESS ROCK
Oil on canvas
24" × 16" (61cm × 41cm)
Private collection

3 | Brush Shaping and Paint Loading

In creating the brushstrokes you want, much of the important work is done even before you touch your brush to canvas. Laying the paint on the picture is the last of a series of techniques. If you fail to understand and execute any of the maneuvers that precede that ecstatic moment of self-expression, the paint likely will not be in a position to do as you command.

Although a large number of different techniques can be used to create an oil painting, the vast majority of the work is a matter of repeating the same handful of simple procedures again and again with mostly minor variations. Let's quickly run through a typical sequence of adding a brushstroke to a painting.

A good deal of the time, you need to clean your brush between strokes and with the same motions shape the body and tip in preparation for making the kind of stroke you want. Then the paint is loaded (picked up by the brush). Finally you apply the paint where and how you want. Even though chapter four will provide in-depth instruction on application mechanics, I think it will be helpful to include a bit about application now so that you can see the cleaning, shaping and loading in context.

This instruction may appear to be nitpickry in the extreme since we are in effect getting on our hands and knees at palette level to get a "brush's-eye view" of the most basic procedures. But for those who are searching for exactly the right type of stroke for certain applications (and who else would be using this book?) there is no way around acquiring these skills. But be of good cheer! Even though these procedures seem tedious, in a short time after mastering them they become second nature, and you'll hardly notice you're doing them, which will free your mind for other pursuits—like starting up a conversation with that attractive someone in painting class.

LUNCH PALS
Oil on panel
16" × 16" (41cm × 41cm)
Private collection

Between-Stroke Cleaning and Shaping

The importance of between-stroke cleaning lies in more than just keeping the brush free of unwanted colors. As we stroke merrily along, paint works its way into the body of the brush, coating all the bristles and making the body thicker and less flexible. In the following pair of photos you can see that the paint-clogged brush looks like a hippopotamus on a Twinkie™ binge compared to its svelte self after a quick cleaning. The cleaned brush can be shaped to a much finer point for careful and crisp brushwork and can be maneuvered around outlines much easier.

When done properly, the cleaning procedure shapes the brush in preparation for the next stroke. You can also do additional shaping after the cleaning. I'll deal with that separately.

Before charging into "how to clean," let's tackle "when to clean." Clean whenever the load of paint in your brush will interfere with any new color you want to mix or apply, or whenever you need the brush to be better shaped and more flexible than in its clogged state.

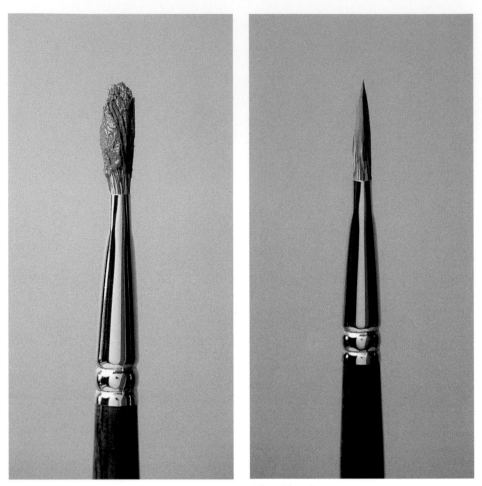

Before Cleaning
Compare the thick shape of this paint-clogged filbert (side view) to its cleaned appearance in the next photo. The paint buildup makes it difficult to maneuver and impossible to obtain a decent point.

After Cleaning
A quick cleaning restores the brush's shape, aligns the hairs and points the tip.

Methods of Cleaning and Shaping

By now, most of you know the drill: Pull, don't push! I can hear the tumblers falling into place. And you already know why: reduces wear, lines up the hair— the nearest thing to a mantra this book has to offer.

Rag in Hand

Holding the rag in your palette hand, pull the brush straight through, using the thumb and forefinger of your rag hand to firmly squeeze and flatten the brush body and tip.

Rag at Side

If you hang a rag from your belt as I do when painting on location, firmly pull the brush in any direction that is convenient. Pull so that the pressure is against the body of the brush rather than against the ferrule. Do both sides.

Rag on Flat Surface

If you work on a palette table as I do most of the time, clip the rag to the surface so it won't move when you drag brushes across it. (I attached a couple of spring-operated cabinet door hinges for the purpose.) Firmly pull the brush body across the rag, maintaining pressure on the body and not the ferrule. Do both sides.

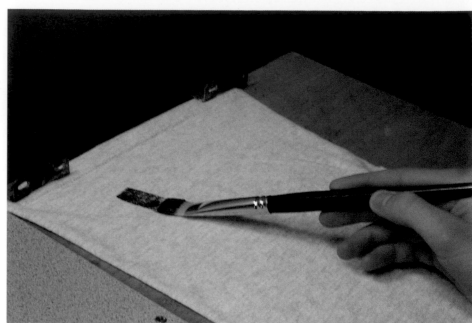

With Palette Knife

Sometimes a lot of paint builds up in the brush body near the ferrule. A palette knife can be used to exert more pressure to squeeze that paint out. This method also tends to trim errant bristles from synthetic-fiber brushes. Hold the brush at a low brush-to-palette angle. Then, with the knife blade nearly parallel to the palette, squeeze with the knife's rear edge from the base of the brush hairs and move toward the tip. Turn the brush over and repeat. As you can guess, doing this carelessly can leave your brush hacked and moaning.

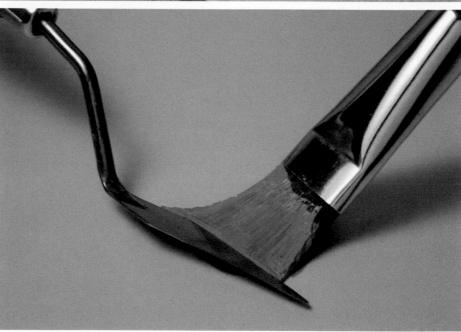

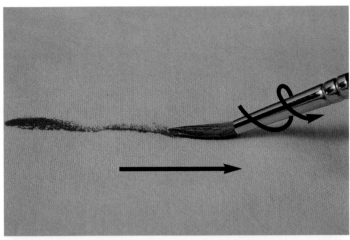

Cleaning and Shaping Rounds

For cleaning rounds, including script liners, pull the brush body across a flat rag or through a handheld rag. As you pull the brush in a straight line, rotate the handle with your fingers. This will simultaneously clean the brush all around and shape the tip to a fine point.

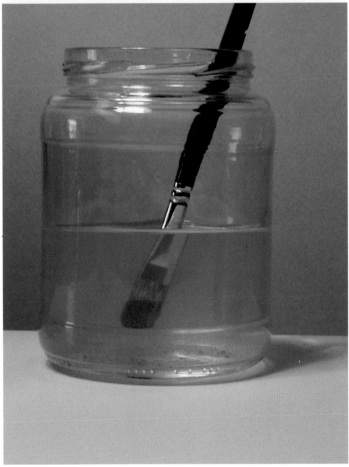

In Solvent

If you need to use a brush for an entirely different color, it may be necessary to clean it with solvent. Swishing your brush around in solvent will remove far more paint than cleaning with a rag. Avoid mashing the brush straight down on the bottom of the solvent container since this will contribute to bristles splaying and even breaking at their bases. Use a pulling motion to wipe the solvent from the body, then shape the brush with a rag.

CLEANING WITH A DAB OF MEDIUM

If you don't want to bother with a full solvent bath for your brush but need to eliminate more color than just pulling across a rag can accomplish, pick up a dab of medium on your brush and work it around on the palette into the bristles. The medium's oil and solvent will loosen quite a bit of paint. Wipe and shape the brush and clean the mess from your palette.

A Tip on Cleaning Water-Soluble Oils

Water-soluble oils require a somewhat different approach than regular oils when it comes to clearing a brush of one color to start with another. When a brush laden with water-soluble oils is swished around in a container of water, the paint, for some mysterious reason, becomes rather gummy. The first couple of brushes might clean up all right, but as the proportion of paint to water increases, the water becomes rather scummy and less and less of the paint is removed. The bristles become downright thick with oddly sticky paint.

Instead, use the brush body to carry a bit of water to the palette. Then, with a pulling motion, work the water into the brush body and the paint out. Wipe and repeat. Two or three quick shots of this procedure will adequately clear your brush to work with a clean color. Shape the brush with a rag, wipe the sludge from your palette and away you go. I've found I need to use far less water with this method (which is a real help when painting on location), and my water remains clean for washes.

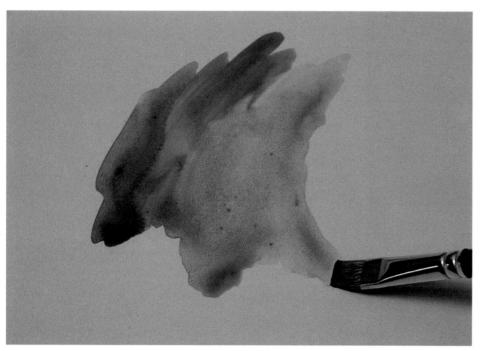

Water-Soluble Oils
For between-color cleaning of water-soluble oils, put a little puddle of water on a clean spot of your palette and work the brush around in it. Wipe and repeat once or twice, then shape the brush on your rag and clean the dirty puddle from your palette.

CAUTION!

Never (a *never* without equivocation), never shape your brushes with your mouth. This shaping method is the best way, short of intravenous injections, to ingest toxins. And even paints presently labeled nontoxic may at some time in the future be discovered to be harmful in some way. Also, as tempting as it may be to hold a brush in your mouth for a moment while using another, it's advisable to keep brush handles out of your mouth. Oil paint travels. You unwittingly get a smear on the heel of your hand and before you know it, it's on your shirt, your nose, your brush handle, the front door knob, your neighbor's cat, and everyone is laughing (or yelling) at you. We can at least keep it out of our bodies.

Chisel-Shaping Brushes

The previous methods of between-stroke cleaning and shaping will line up brush hairs and bring the tip to a fairly good point. If, however, you are doing fine work, especially careful lines, you will likely need to take an extra step to shape the tip into the sharpest, straightest edge possible. This technique can be used for rounds just as effectively as for flats, brights and filberts.

Hold the brush at about a 45-degree brush-to-palette angle. By pushing down and very slightly forward, the brush tip will be compressed and formed into a straight chisel-like edge. Now you're ready to load a thin bead of paint that can be used to make a very fine, controlled line or a carefully placed highlight ridge.

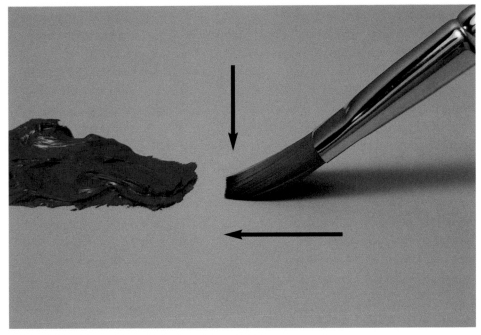

Chisel-Shaping a Brush on Your Palette
After cleaning and shaping the brush on a rag, hold the handle at about a 45-degree brush-to-palette angle. Push down and very slightly forward.

Shovel Loading

I'm going to cover several loading methods for picking up paint with a brush. As you go through this material, you'll discover that each type of loading is particularly apt for certain kinds of brushstrokes. For this reason it's necessary to learn to think about what kind of stroke you want to lay down before you actually pick up the paint. If you're beginning to feel a touch of brain fever at the thought of having to evaluate every stroke of every painting for the rest of your life, relax. Once again, most of the time we repeat the same type of stroke over and over. We do the figuring when we switch to a different type of applica-tion—say from painting a sky to painting branches. Then it's repeat, repeat, repeat the new type of stroke.

Shovel loading involves placing the tip on the palette, holding the handle at a medium to low brush-to-palette angle and pushing lightly down and forward into the paint pile. The deeper you push into the pile, the larger the load of paint you pick up. Turn the brush over to apply. In this way you load an easily controlled package of paint anywhere from a razor-thin line along the tip to a medium amount for a nice clear stroke that will mirror the shape of the brush you're using. The paint is on one side of the brush so there's no guessing about how paint on the top might irregularly flow into the stroke and create more thickness than you intended.

Shoveling is great for fine to medium-careful stroke work but does not lend itself to loading a large mass of paint. Picking up a larger glob of paint requires pushing deeper into the paint pile, and the greater amount of paint resists the hairs and push-es them out of line. For managing larger quantities of paint, skip ahead to Tip Pull Loading (page 52) and Body Loading (page 55).

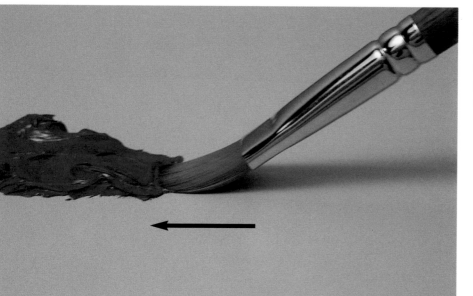

Shovel Loading
Place the tip on the palette, holding the handle at a medium to low brush-to-palette angle, and lightly push the tip down and forward into the paint pile. Turn the brush over to apply.

Drawing Chisel Tip Along the Edge of the Paint Pile

Here is another method for loading a very thin line of paint just on the brush tip. Smooth the paint at the paint pile's edge to a thin depth. Then, after chiseling the brush tip, draw it in a slight arc across the very edge of the pile, picking up pigment only on the very tip. This is the most consistent way to get a superthin line of paint on your brush tip for very fine lines.

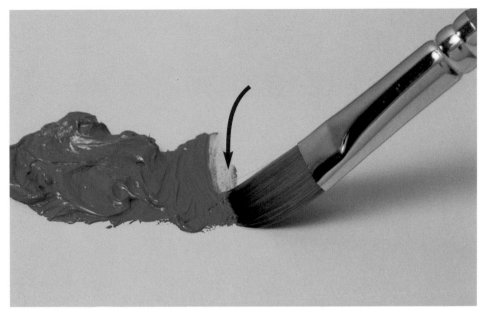

Drawing Chisel Tip Along Edge of Paint Pile
Smooth the paint at the pile's edge to a thin depth. Chisel the brush tip and draw it in a slight arc across the edge of the paint pile to pick up paint only on the very tip.

Chisel Tip With Paint
Chisel-tip shovel loading and drawing a chiseled tip along the edge of a paint pile both give you an extremely thin line of pigment ready for painting delicate lines or other fine detail.

Chisel Load Application

While we've got the paint on the brush, I'm going to jump ahead a little to a few examples of application. I want to set in your mind the basic types of brushstrokes on a dry canvas from these loading methods before we forge ahead into the other complexities of application.

Chisel Shaped and Shovel Loaded: Sample Brushstrokes
Chiseled flats and brights that have been shovel loaded can make controlled, precise strokes very much like a calligraphic C pen point.

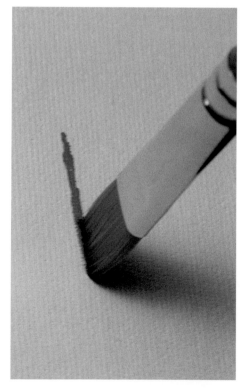

Painting a Fine Line
Load a precise bead of paint on the chiseled tip. Holding the handle perpendicular to the canvas and barely touching the paint to the surface, pull the brush in line with the chiseled tip.

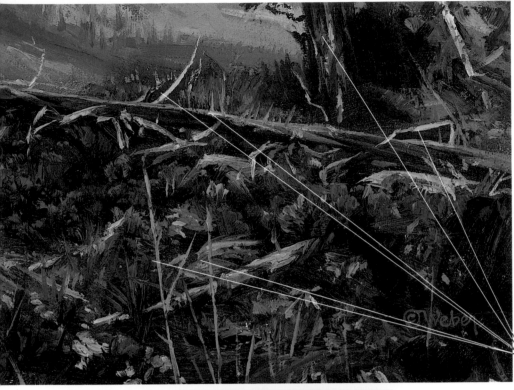

Chisel-Tip/Shovel-Loaded Strokes: Detail
Much of the careful work in this picture, including all branches, the most prominent weeds and grasses and the bark highlights, were painted using chisel-tip/shovel-loaded strokes.

Chisel-tip/shovel-loaded strokes

BATTERED PINE—TETONS
Oil on linen
15" × 10" (38cm × 25cm)
Collection of the artist

Tip Pull Loading

When it's necessary to pick up a large amount of paint for an application or when the precision made possible by shovel loading is not needed, pull loading is a handy technique. This involves pulling through or over the top of a paint pile to pick up pigment on the bottom of the brush. I'm going to cover four basic variations of pull loading; the first of which is tip pull loading.

To load in this fashion, hold your brush at a medium to steep angle (up to 90 degrees) and sweep the tip through the top or edge of the paint pile. The more paint you want, the deeper you go with your pull. This works very well for picking up small to medium amounts of paint for strokes that don't need to be terribly precise. A quick swipe at the paint pile, over to your canvas, then you're ready for the next stroke.

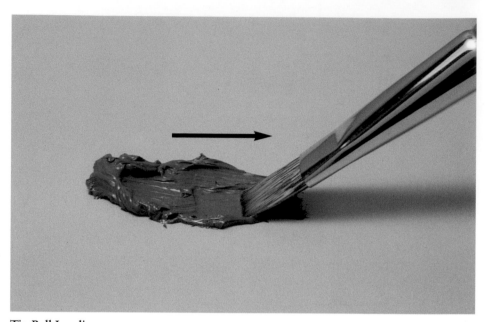

Tip Pull Loading
Hold your brush at a medium to steep angle (up to 90 degrees) and pull the tip through the top or edge of the paint pile.

Tip Pull Load Ready to Go
The brush tip holds a nice load of paint.

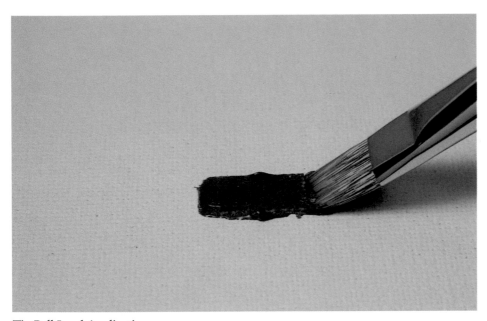

Tip Pull Load Application

*With the paint side down and using a medium brush-to-canvas angle,
simply pull across where you want the stroke. Notice that you get a
much less precise stroke than with shovel loading.*

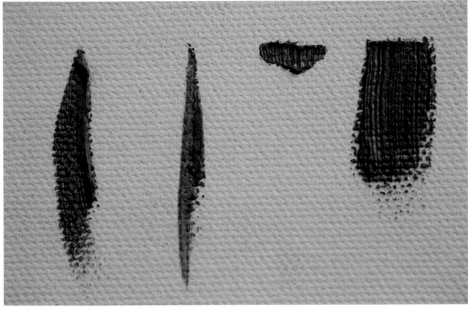

Tip Pull Loaded: Sample Brushstrokes

*Compared to the chisel-tip/shovel-loaded strokes, these are a bit
less precise.*

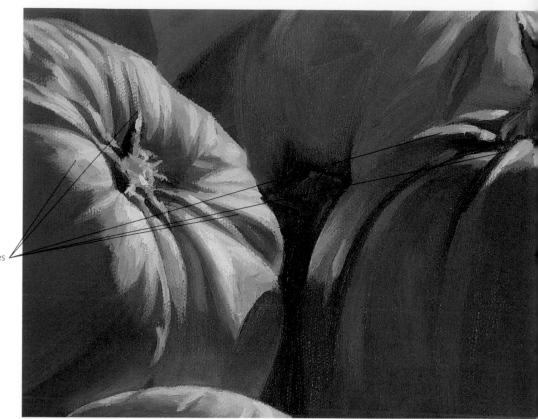

Tip-Pull-Loaded Strokes: Detail
In this detail of Pumpkins, all the highlights are painted using tip-pull-loaded strokes.

Tip-pull-loaded strokes

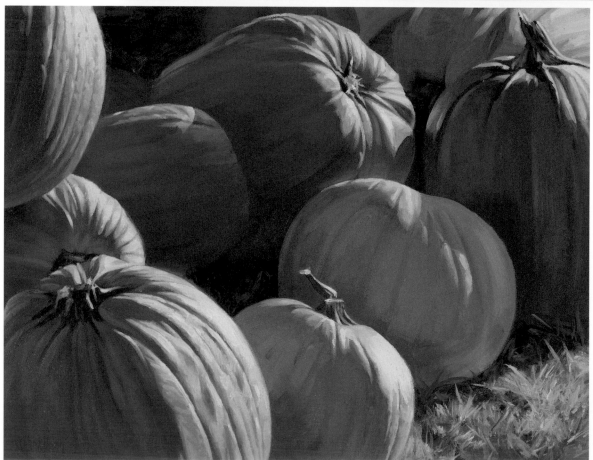

PUMPKINS
Oil on canvas
14" × 18"
(36cm × 46cm)
Collection of the artist

54

Body Loading

Body loading requires using a shallower brush-to-palette angle than tip loading and has several uses. First, it makes it possible to pick up a much larger load of paint for impasto strokes or just carrying a lot of paint to cover a large area. The large load of paint can also be applied in long, sweeping strokes. Since the paint is distributed along the body of the brush, the handle can be lowered as the stroke progresses, in the process laying down more pigment. For skimming applications (which I cover on pages 92–93) you use body loading to spread the paint thinly along the entire body of the brush.

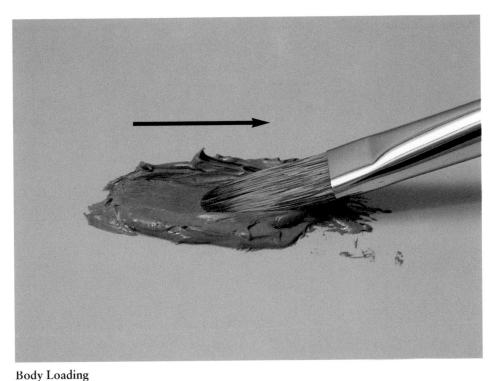

Body Loading
Hold the brush at a shallow brush-to-palette angle, then pull the body of the brush over the top of the paint pile.

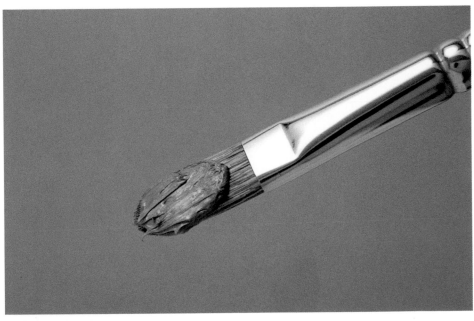

Body Load Ready to Go
In contrast to tip pull loading, see how body loading distributes paint along the brush's body

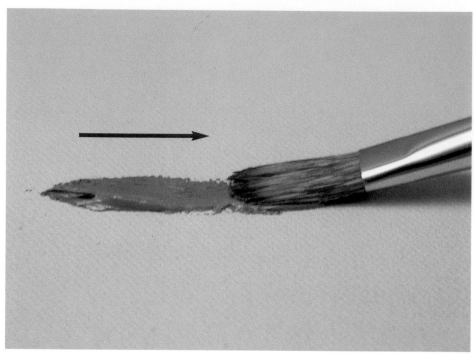

Body Load Application for Impasto Stroke
To make a thick impasto stroke, apply the paint at a very shallow brush-to-canvas angle, using light pressure.

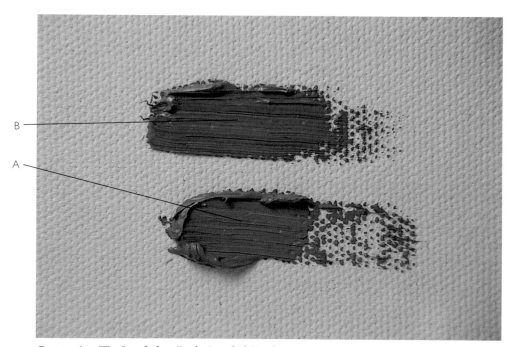

Comparing Tip-Loaded to Body-Loaded Strokes
The body-loaded stroke (A) is much thicker than the tip-loaded stroke (B).

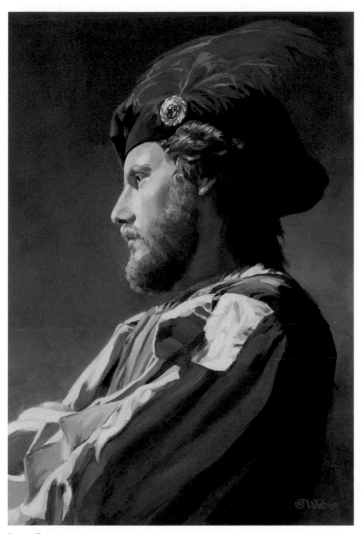

RED FEATHER
Oil on canvas
20" × 16" (51cm × 41cm)
Collection of the artist

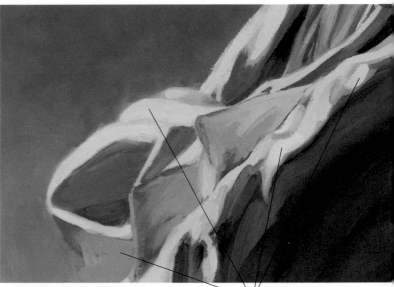

Body-Loaded Strokes: Detail
The body-loaded strokes, painted with nos. 4 and 6 bristle filberts, show up especially well in the yellow highlights of the sleeve.

Body-loaded strokes

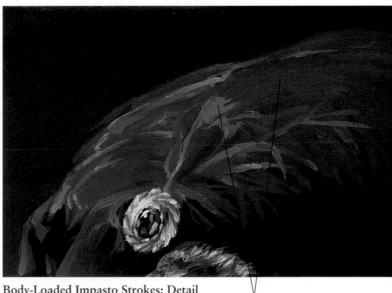

Body-Loaded Impasto Strokes: Detail
Using a no. 8 bristle filbert, I painted a few thick impasto strokes to enhance the texture of the feather.

Body-loaded
impasto strokes

Body Fill-Up

In contrast to body loading, where the paint is on the brush, the goal of the body fill-up is to soak thin-consistency paint into the brush body for particular applications. The body fill-up is used for painting long, washy strokes that give an impression of breezy spontaneity or soaking up lots of thin paint for washing in large areas. It's also a necessary skill to master for using a script liner for long, delicate lines. The long hairs of script liners are too weak to hold their point while manipulating thick-consistency paint and will work properly only with very fluid paint that easily flows from the brush body.

To execute the body fill-up, first thin the paint with medium or solvent (or water for water-solubles) down to no. 6 or 7 consistency so the paint will actually soak into the brush body. For a script liner, pull the entire brush body gently through the thinned paint, rotating the brush handle as you pull. It may require pulling through the paint more than once to soak up an adequate amount of pigment. For other brushes, place the whole body of the brush in the thinned paint and gently work the brush around until it soaks up as much paint as you'll need. If your paint is extremely fluid, you may need to exercise extra care in getting your brush to the canvas without dripping. Try holding the brush tip upward. If you see a drip developing on the bottom of the brush, rotate it top to bottom.

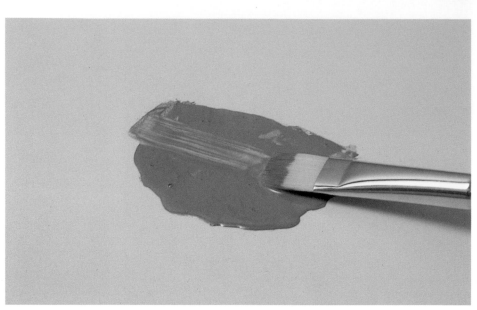

Body Fill-Up
Thin the paint with medium or solvent to a no. 6 to 7 consistency so the paint will soak into the brush body. Place the body of the brush in the thinned paint and gently work it around until it soaks up as much paint as you'll need.

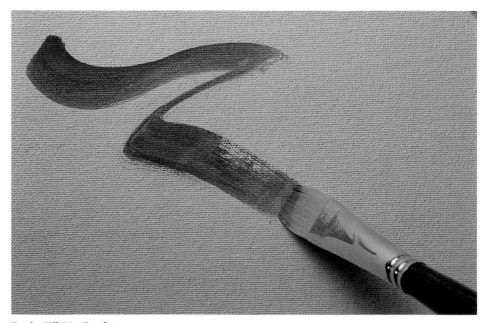

Body Fill-Up Stroke
Create a long, washy stroke with a no. 10 bristle bright. This type of loading and stroke can give an impression of breezy spontaneity.

Body Fill-Up Stroke: Detail
*Soaking up a mixture of Terre Verte mixed with Raw Umber,
Titanium White and a touch of Yellow Ochre thinned to a no. 6
consistency, I briskly painted in the background with a no. 12
bristle bright.*

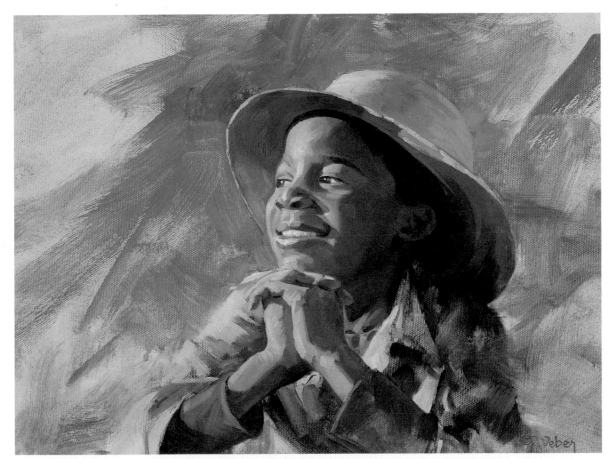

STRAW HAT
Oil on canvas
11" × 14" (28cm × 36cm)
Collection of the artist

Multicolor Loading

MATERIALS LIST

<u>Holbein Duo Aqua Oils</u>
Base Palette

- *Burnt Sienna*
- *Cream (Naples Yellow)*
- *Light Yellow (Cadmium Yellow Light Hue)*
- *Madder*
- *Marine Blue (Phthalo Blue)*
- *Payne's Grey*
- *Raw Umber*
- *Terre Verte*
- *Titanium White*
- *Ultramarine Blue*
- *Yellow Ochre*

<u>Mediums</u>
Water
Winsor & Newton Artisan Water Mixable
 Linseed Oil

<u>Brushes</u>
Synthetic Bristles

- *Flats nos. 4–10*
- *Brights nos. 4–12*
- *Filberts nos. 4–8*

Soft Synthetics

- *Rounds nos. 1, 2 and 8*
- *Flats ¼-inch (6mm) and ½-inch (12mm)*
- *Brights ¼-inch to 1-inch (6mm–25mm)*
- *Filberts ⅛-inch to 12-inch (3mm–300mm)*

Multicolor loading involves picking up two or more colors on a brush to create one stroke that blends as you apply the paint or to make interesting and descriptive streaks. To be honest, I don't use this technique, but I've seen paintings that employ it to create remarkable marblelike effects.

It helps to use thinner-consistency paint so that the pigments blend together during the pull and are fluid enough to give you a long, flowing stroke.

The following series of illustrations will give a basic progression for loading a brush with three colors. You can create quite a few possibilities using these general guidelines.

1 | Load the First Color

Using a wide flat, load the first color (no. 4 consistency or thinner) from the paint pile on one corner of the brush.

2 | Load the Second Color

Load paint from the second paint pile on the brush's other corner.

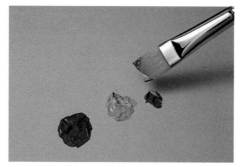

3 | Add a Third Color at One Corner

Touch just the corner of the brush into a third pile of pigment.

4 | Application

Pull the brush in one smooth motion. The most fun is in changing directions and having the colors obediently trail along in formation.

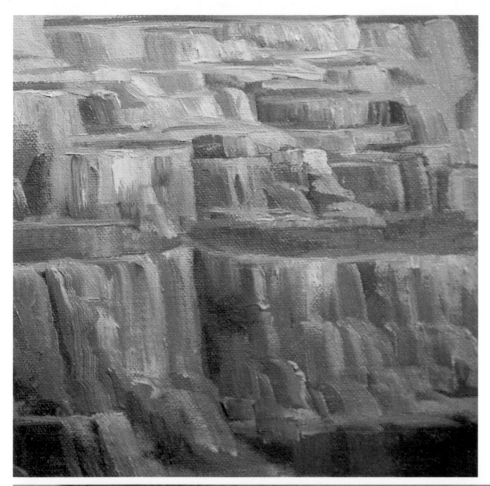

Detail of Multicolor-Loaded Strokes
Many of the varicolored streaks on the amazing travertine in this Yellowstone National Park scene were painted with multicolor-loaded strokes.

MINERVA TERRACE
Oil on canvas
12" × 16"
(30cm × 41cm)
Collection of the artist

4 | Paint Application

We've finally arrived where the paint meets the canvas. With each of the previous loading segments, I touched on some of the possible paint applications; that was just wading in the shallows. Get your scuba gear out now because we are diving into paint application to study it in depth.

Keep in mind all that you just learned about cleaning, shaping and loading, the techniques foundational to purposeful brushstrokes. Now we move on to factors such as surface tooth, grip, brush angle, pressure and motion, as well as several other elements that must be taken into account in order to control brush and paint during application.

Those of you who are inclined to try to swallow things whole may be starting to feel a little panicky at the prospect of assimilating this mass of new techniques all at once. There's no need to worry. We'll take one factor at a time in easy bite-size units. Much of this information you'll discover you already sort of knew but just haven't had clearly explained and organized for you.

Have I brought up the issue of practice yet? (I'll ignore that rude noise you just made.) There's no real mystery to the methods I'm teaching here; you'll understand right away. But getting to the point where you can select and hold the right brush in the most effective way to mix, manipulate and apply the paint for the strokes you want without painful concentration and endless trial and error requires one simple thing available to us all: *practice*. And not just practice, but practice, practice, practice, practice, practice, practice.... That's where it moves from head-knowledge skill to skill you naturally apply, like driving a car. And, happily, your chances of winding up in the hospital because you used a filbert when you should have used a round or pushed when you should have pulled are slim to none.

RIVER BEND
Oil on canvas
15" × 13" (38cm × 33cm)
Collection of Drew McGee

Surface Tooth

The first thing affecting your stroke is the degree of texture, or tooth, your painting surface possesses. A fine-weave canvas or a smoothly sanded gesso panel allows for fluid, easy blending during paint application. This type of surface texture is a spectator to the painting process. The rougher the surface texture used, whether coarse linen or panels textured with modeling paste, the greater is the effort required to work paint into the low points of the surface tooth. Blending colors together on the rough surface is usually more demanding, but you gain possibilities for interesting interplay between surface texture and paint. The texture in effect becomes an active participant in the painting process. In chapter five, in the sections about skimming, glazing and scumbling, I discuss how surface tooth affects these blending variations.

Smooth-Textured Surface
The smoothly sanded gesso panel facilitates fluid, easy blending. This surface gives only the very slightest texture to the paint.

Medium-Textured Surface
This medium-weave acrylic-primed canvas imparts a little texture to the brushstrokes, opening up modest painterly effects impossible on a smoother surface. A bit more effort is needed to work the paint into the tooth.

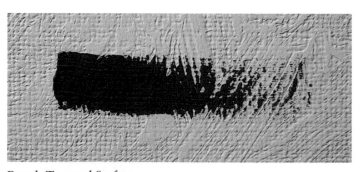

Rough-Textured Surface
The heavy tooth of this medium-coarse linen is drastically increased by the addition of a layer of white oil ground roughly brushed on. The possibilities increase for interesting interplay between the surface texture and paint. Extra effort is needed to work the paint into the weave.

Painting on a Smooth Surface
The smooth surface of this painting enhances its peaceful mood. Also, a strong surface texture would create a multitude of little highlights that would make a lot of distracting sparkles in the soft shadows.

LANTERN AND PLUMS
Oil on panel
20" × 24" (51cm × 61cm)
Collection of Bill Berkley

Grip

The grip you use for holding your brush is partly a matter of personal preference and partly determined by the type of stroke you are making. Two basic grips are used in oil painting: the pencil grip and the baton grip.

PENCIL GRIP

The pencil grip allows for finger control of the brush. Holding the brush near the ferrule enables you to have maximum control for very careful, detailed brushwork. Gripping the brush at the handle's end makes it possible to comfortably hold the brush perpendicular to the canvas for long, sweeping strokes that require touching the surface with only the bristle tips, as in very light blending. At the same time this grip makes any long, body-loaded types of strokes difficult and uncomfortable.

BATON GRIP

The baton grip operates more with arm and wrist than fingers. Don't look to this grip to provide fine motor control for detail or blending. Its chief advantage is in making all manner of paint applications with a low brush-to-canvas angle, including all strokes created by the various body-loading methods, far easier than the pencil grip. The baton grip is also well suited for light, skimming strokes.

For both baton and pencil grips, holding the brush at the handle's end makes it possible to stand farther back from the canvas to have a continuous overall view of how the picture is developing.

Pencil Grip Near Ferrule
Holding the brush near the ferrule with the pencil grip enables you to have maximum control for very careful, detailed brushwork.

Pencil Grip at Handle's End
Holding the brush at the handle's end with the pencil grip makes it possible to position the brush perpendicular to the canvas for sweeping, blending strokes that require touching the surface with only the bristle tips.

Baton Grip
The baton grip works best for paint applications with a low brush-to-canvas angle. It is especially well suited for light, skimming strokes and thick impasto application.

Brush Angle Mechanics

The most important thing to understand about this esoteric-sounding discipline is that a steep brush-to-canvas angle is required for smooth paint application and blending and working paint into surface texture, and a shallow angle is necessary for thick brushwork. The following hows and whys will give you a better grasp of what's happening between brush, paint and canvas to help you get the results you want.

STEEP ANGLE

Painting with brights and flats at or around 90 degrees to the painting surface evenly flattens out the paint, which is necessary for a smooth painting technique. The steep angle also works best for smooth blending, because the only parts of the flats and brights in contact with the paint—the hair tips—work in unison.

Holding the brush at a steep angle makes it possible to exert more pressure on the paint and more efficiently force it into the weave. There are three reasons for this. First, all contact and thus all pressure is confined to the brush tip. Second, because only the bristle tips touch the paint and surface, they are able to poke into the valleys of the surface texture and force the paint into them. Third, when accompanied by downward pressure, a steeply angled stroke causes the bristles to flex, in effect turning them into a pack of springs with their tips flattening out the paint and forcing it into the surface tooth.

Depending on your level of dexterity, you can achieve an extremely light touch with either a steep or shallow angle. With the steep angle, though, you have far more control, because you touch the surface with only the very tips of the hairs. You can see and feel exactly what they are doing. When using a shallow angle, you can't see what's happening under the belly of the brush and any part of the body will contact the surface and affect it. I don't at all mean to disparage shallow-angle paint application; it's just that for careful, smooth blending, go with control, and you achieve greatest control with a steep angle.

SHALLOW ANGLE

With a brush-to-canvas angle of less than 30 degrees, shallow-angle application brings the entire brush body into contact with the surface, thus spreading the pressure over a much larger area. The sides of the hairs lie flat against the canvas and can't dig into low spots of the weave. As a result shallow-angle strokes don't flatten out the paint nearly as much as the steep-angle strokes. If lightly applied, they allow the paint to keep its mass and shape, which is exactly what is needed for any kind of thick brushwork, including impasto.

With the pressure spread out over the entire brush body and not confined to the tip, shallow-angle strokes create uneven pressure. At the same time, this reduces precise control and it makes possible more organic-looking brushwork.

Because a shallow angle doesn't force paint into surface tooth, it enables you to skim over an area, with pigment landing on peaks and skipping over valleys.

Steep to Shallow Brush Angle

Painting at a brush-to-canvas angle steeper than 45 degrees evenly flattens out the paint, which is needed for smooth painting and blending techniques. Working at a shallow angle of 30 degrees or less is needed for thick brushstrokes. Shallow-angle application brings the entire brush body into contact with the surface, thus spreading the pressure over a much larger area.

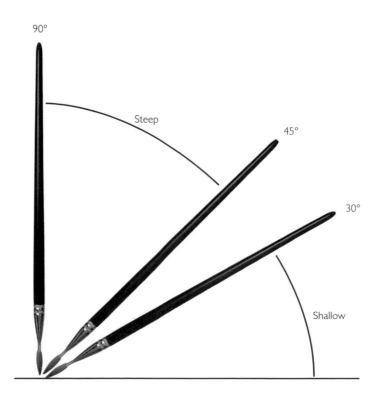

Brush Pressure

The previous segment dealt with pressure as it relates to brush angle. When it comes to plain old pushing harder, there are a couple of things to know.

Downward pressure flattens and spreads the paint as it spreads out the brush hairs. Therefore, a broader stroke is accomplished by pressing the brush downward. To cause a stroke to widen as it progresses, exert increasing pressure as you pull. If it's the opposite effect you want—that is, thin strokes—then apply only light pressure when laying down a stroke. Using a light touch in which only the paint contacts the canvas also keeps the hairs close together.

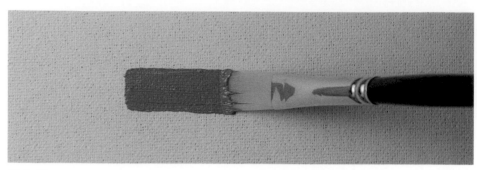

Light Pressure
Exerting light pressure allows the hairs to stay together for a thinner stroke and flattens out the paint less than exerting heavy pressure does.

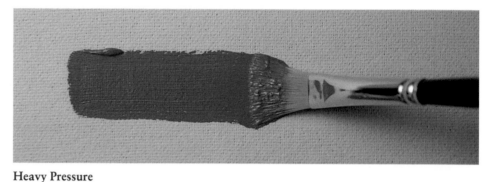

Heavy Pressure
Heavy pressure spreads out the bristles much farther for a wider stroke and flattens the paint more than light pressure does.

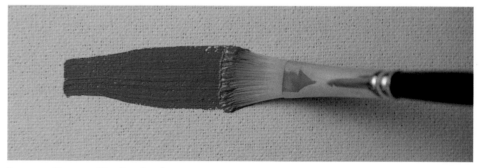

Increase Pressure During Stroke
It's possible to change the stroke from narrow to wide by increasing pressure on the brush during the stroke.

Motions

For those of you who skipped ahead to this spot without reading the previous material, I shall reiterate my redundant refrain. Pull, don't push the brush. It's the same for between-stroke cleaning, mixing paint, applying impasto strokes, glazing, whatever, etc., ad nauseam. Pulling lines up the hairs for better control and reduces wear on the brush tip. Pushing splays the bristles out of alignment and wears out brushes quickly.

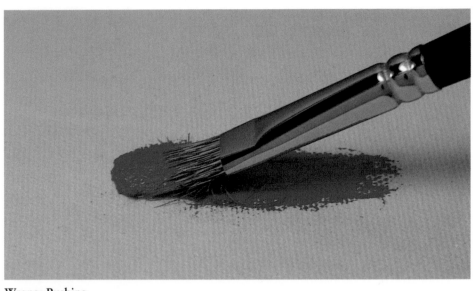

Wrong: Pushing
Pushing the brush to apply paint reduces control by splaying the bristles and greatly increases wear.

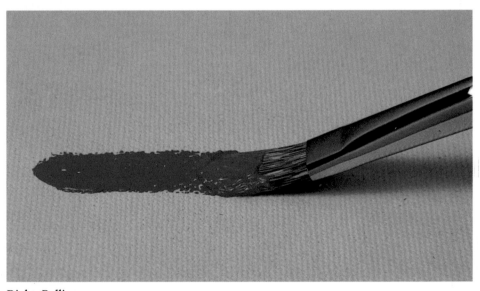

Right: Pulling
Pulling keeps the hairs lined up for better control and keeps wear to a minimum.

Down With Dabbing!

One of the most frequent mistakes beginning and intermediate painters make is dabbing. By dabbing I mean holding the brush, especially a round, perpendicular to the canvas and pushing directly into the surface to apply the paint. This motion causes the bristles to splay and creates an irregular crown-shaped blotch of a stroke. In addition, it wears out the brushes. (By now you've gathered that I'm a stickler about this.) And as if that weren't enough, it sets my teeth on edge.

On occasion, a dab gives you just the right effect, but what I usually observe are untutored artists dabbing right and left trying to get all manner of effects but with predictably miserable results. If dabbing is the disease, this book is the cure. And if you've read through to this point, you've already discovered lots of alternatives to dabbing.

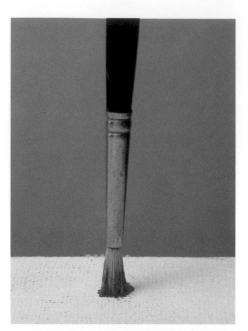

The Dagnab Dab
By dabbing I mean holding the brush perpendicular to the canvas and pushing directly down to apply the paint. This causes the bristles to splay and creates an irregular crown-shaped blotch of a stroke. Dabbing is very rough on brushes.

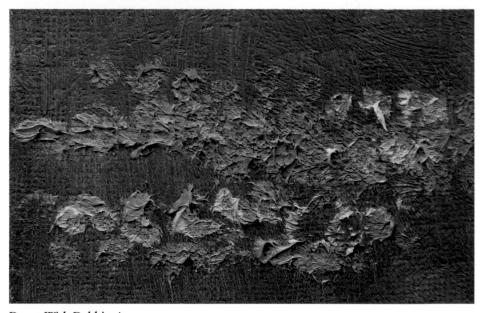

Down With Dabbing!
I had to force myself to paint this dabbing example. Notice the distinctive, splotchy look of the dabs.

Wet-Into-Wet Mechanics

Oil paints with their slow drying time have a decided edge over all other painting mediums when it comes to blending colors and values. To reap the full benefit of that wonderful quality, you need to have at least a passing understanding of working wet-into-wet. In chapter five, the blending chapter, we'll delve into actual wet-into-wet techniques, but for now a few simple guidelines will suffice.

First of all, remember the peanut-butter-on-jelly principle of chapter two (page 31).

When the viscosity of the paint on the brush is greater than that of the layer you're painting into, and even more so when the bottom paint is thick, the paint on the brush will skid over it instead of blending in smoothly.

When painting into a wet area, the brush with its new color simultaneously deposits its color and picks up the underlying hue. One result of this is that the color of the stroke actually changes as it progresses, and the thicker the base paint, the quicker the change occurs. Because of this, before you work wet-into-wet, try to be aware of how the wet base color will alter the color you're adding.

Not only does the stroke change color, but you now have a new color, a blend of the base and brush pigments, on your brush. If you want to keep the color you're adding relatively clean, it's necessary to wipe your brush after every stroke or two.

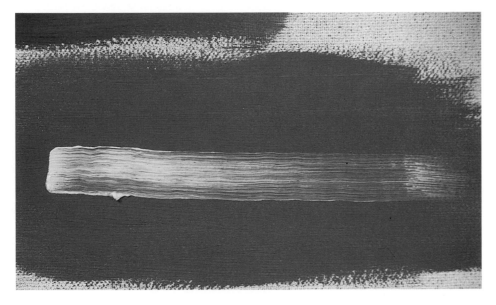

A Wet-Into-Wet Stroke
Be aware of how the wet base color will alter the color you're adding, because the color of the stroke actually changes as it progresses. In this example the yellow mixes with the blue base to create green, even with the single stroke.

Brush Shape Affects Beginning Shape of Stroke

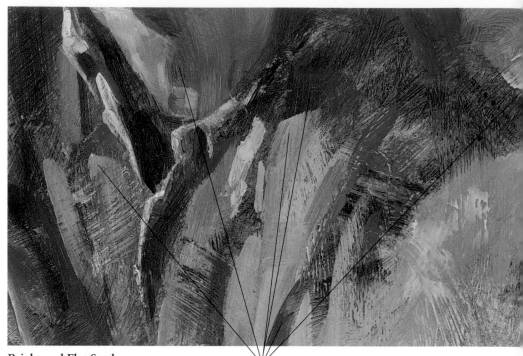

As indicated in chapter three, each type of brush makes a distinctive mark. These characteristics can come into play in all sorts of applications, especially when executing loose and painterly passages. Rather than painstakingly delineating and filling in areas of color, you can deftly suggest many things with the proper use of a single stroke of the right shape brush. These examples give an indication of some of the possibilities.

BRIGHTS AND FLATS

Brights and flats make a crisp square shape for the beginning of strokes.

Bright and Flat Strokes
This detail shows a number of strokes created by the square-ended tips of brights and flats.

Strokes created by brights and flats

TATTERED AND TORN
Oil on textured panel
16" × 12" (41cm × 30cm)
Collection of the artist

FILBERTS

The smooth oval tips of filberts are perfect
for creating strokes with rounded ends.

OIL LAMP AND FLOWERS
Oil on canvas
28" × 20" (71cm × 51cm)
Collection of Jean Orr

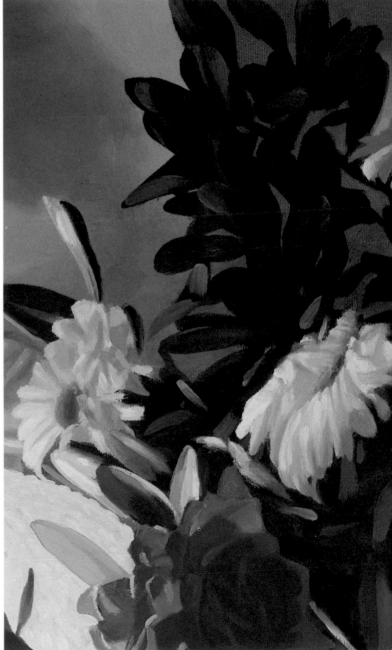

Filbert Strokes
*Filberts worked wonderfully to quickly paint
the oval-ended leaves and petals in this detail.*

BRISTLE FAN BRUSHES

Bristle fan brushes are good for multiple streaks, wispy clouds or areas of grass and leaves. The soft-haired fans lack the strength to provide enough control for this sort of work. Save them for careful blending.

Applying a Fan Brush Stroke
Here, I use a no. 6 bristle fan to apply a streaky skein of clouds to a sunset sky.

Detail of Fan Brush Work
Most of the clouds here have been brushed in with a bristle fan.

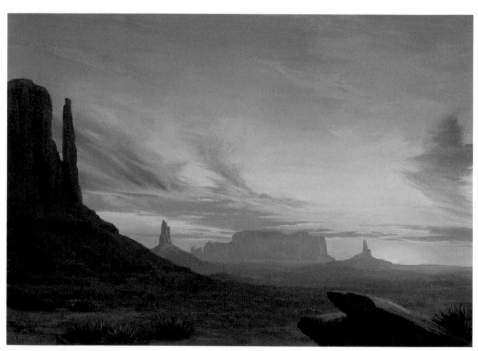

LAND OF RED AND ORANGE
Oil on canvas
14" × 20" (36cm × 51cm)
Collection of the artist

Lifting Up

It's time to challenge Newtonian physics with a bit of "What goes down must come up." We lay a stroke down, but we have to end it somehow, sometime. It's a simple matter to see how the type of brush used affects the start of a stroke, but you also need to think about how lifting up your brush to end the stroke influences the character of the brushwork.

Ending a stroke with a vertical lift creates a clean, precise stroke end. Using a shallow angle and lifting gradually creates a drawn-out and wispy or ragged end. Surprisingly enough, filberts, brights and flats all make the same kind of stroke endings.

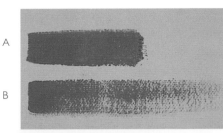

Ending a Stroke
Ending a stroke with a vertical lift in example A makes for a clean, relatively precise stroke end. Example B shows how ending a stroke at a shallow angle and lifting gradually creates a wispy or ragged end.

End Strokes
I've pointed out a few of the more obvious examples of ending strokes with vertical and gradual lifts. If you look closely, you can find many instances of both kinds.

Vertical lift

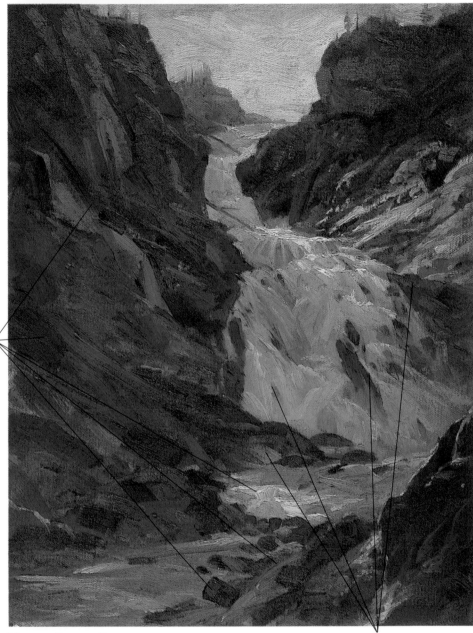

Gradual lift

MYSTIC FALLS—YELLOWSTONE
Oil on canvas
16" × 12" (41cm × 30cm)
Collection of the artist

Highlights and Shadows

Another of the great advantages of oil paint is the paint body itself. As demonstrated earlier, it's possible to lay down luscious strokes of thick pigment. And unlike with acrylics, you don't need to take into account shrinkage as the paint dries. What you put down is what you get.

One way to take advantage of oil paints' body is through highlights. If you are painting a highlight that you want to have an extra bit of sparkle—say a reflection in an eye—use a thicker dab of paint that stands out above the painting surface.

Light will reflect off the little mound of paint like the sun shining off a bald guy's head, thus creating an additional glitter.

Of course, if we can create reflections from highlights where we want them, we can also create them where we don't want them. For example, in painting a dark area that needs to be unobtrusive, unintentionally brushing in heavy paint texture can generate distracting highlight reflections.

The flip side of highlight reflections is shadows. Paint body can create both helpful and distracting shadows. Helpful

shadows would include things like cracks in rocks or shadows in foliage. On the other hand, a poorly planned thick stroke can cast a shadow on an area that should appear smooth—like a girl's upper lip. Suggesting a mustache is not what you're looking for.

Keep in mind that almost all lighting for art will come generally from above. Take this into account as you use paint body to form shadows and highlights.

Highlight
Light reflecting from a little mound of paint creates an additional glitter.

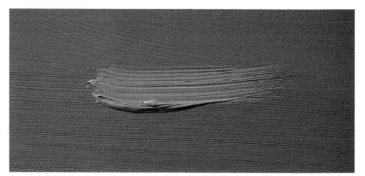

Shadows
Thick strokes can cast shadows that either help or hurt our efforts.

Avoiding Paint Ridges

Some painters have a terrible time when it comes to painting around an object. It seems that no matter how hard they try, they just can't help but get unsightly paint ridges at the objects' edges.

The simplest way to avoid this problem is to paint the object after the background is completed. For those times when this is not practical, here are a couple of tips.

First and foremost, when painting around an object, use a smaller brush and only a very little paint. The bigger the load of pigment you try to maneuver around an outline, the better the chances are you'll end up with a ridge.

If the background has a lot of blending and variation going on right behind the object, work on the background and paint its colors up to about an eighth of an inch (3mm) from the object. Then, with a relatively clean brush, pull the background paint right up to the outline. Instead of adding new paint right at the edge, you're pulling paint that is already under control up to the outline.

Wrong
This is a classic example of unwittingly creating a ridge of paint at the object's edge.

Right
Use a smaller brush. Paint the background close to the object's edge, then, with only a little pigment on the brush, maneuver the paint up to the outline.

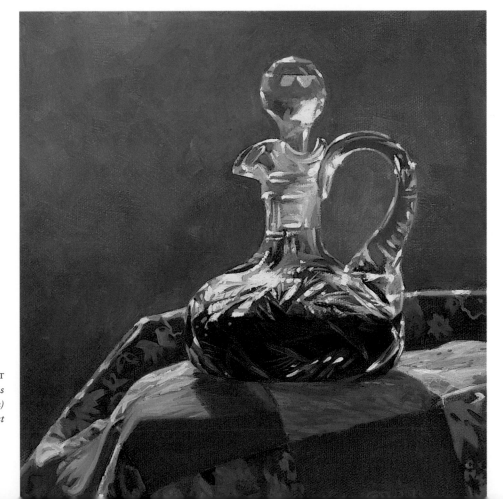

CRUET ON QUILT
Oil on canvas
9" × 8" (23cm × 20cm)
Collection of the artist

Unpainting

One handy technique that has a variety of
applications is wiping away, or what I like
to call *unpainting*. All this amounts to is
using stiff brushes or any of a vast array of
implements to remove paint from an area
of wet paint. It can be precise etchinglike
work done with one of the new paint
squeegees (flexible plastic-tipped tools of
varying shapes) or broadly wiped off with
a rag. There are probably no limits to the
kinds of instruments and textured materials
(sponges and paper towels, for example)
that can be used for unpainting. Any num-
ber of palette knives can be used to gently
remove paint from the surface. It's also
possible to paint a base color, allow it to
dry, then apply a different color for the
second coat, and wipe and unpaint through
it to reveal the base color in places.

Unpainting Implements
*This will give you a basic idea of just a few of the possible implements
that can be used for unpainting and the results they can achieve.*

An Unpainting
*I used a rag and a
large-bristle bright
to wipe streaks in
the upper-left back-
ground to add more
interest to the simple
composition.*

YELLOW ROSES
Oil on canvas
9" × 12" (23cm × 30cm)
Collection of the artist

Enliven Your Paintings With Stroke Variety

Getting so carried away with brushwork that it overpowers the other elements of a painting can be counterproductive. But sometimes, throwing everything in the brushstroke bag of tricks at a canvas can transform an insipid image into an exuberant statement.

What a simple painting like *A Single Iris* lacks in composition, content and complexity, it makes up for with variety in brushstroke and color.

A SINGLE IRIS
Oil on linen
14" × 10" (36cm × 25cm)
Collection of the artist

Highlights

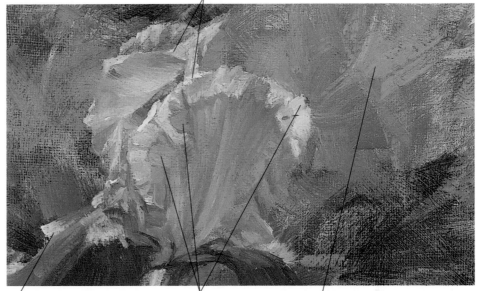

Shovel load: shallow-angle application **Tip pull load:** vertical lift **Body load:** shallow-angle application

Chisel-tip load: steep-angle application, gradual lift **Tip pull load:** shallow-angle application, gradual lift

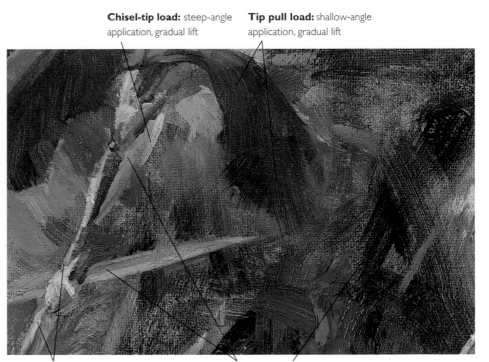

Chisel-tip load: steep-angle application **Shadow** **Body fill-up:** gradual lift

Stroke Interaction Creates Interest
Notice how the various strokes interact on the textured canvas.

5 | Blending Variations

One of the great joys of oil painting is taking advantage of the paint's slow drying time to create all sorts of color and value transitions at our leisure—when it's working, that is. When it's not working, it can be remarkably frustrating. Fortunately, you can easily learn techniques to greatly simplify the task. In this chapter we'll cover wet-into-wet methods, as well as a few wet-into-dry techniques.

WITH CANDLE AND VEIL
Oil on canvas
36" × 24" (91cm × 61cm)
Collection of the artist

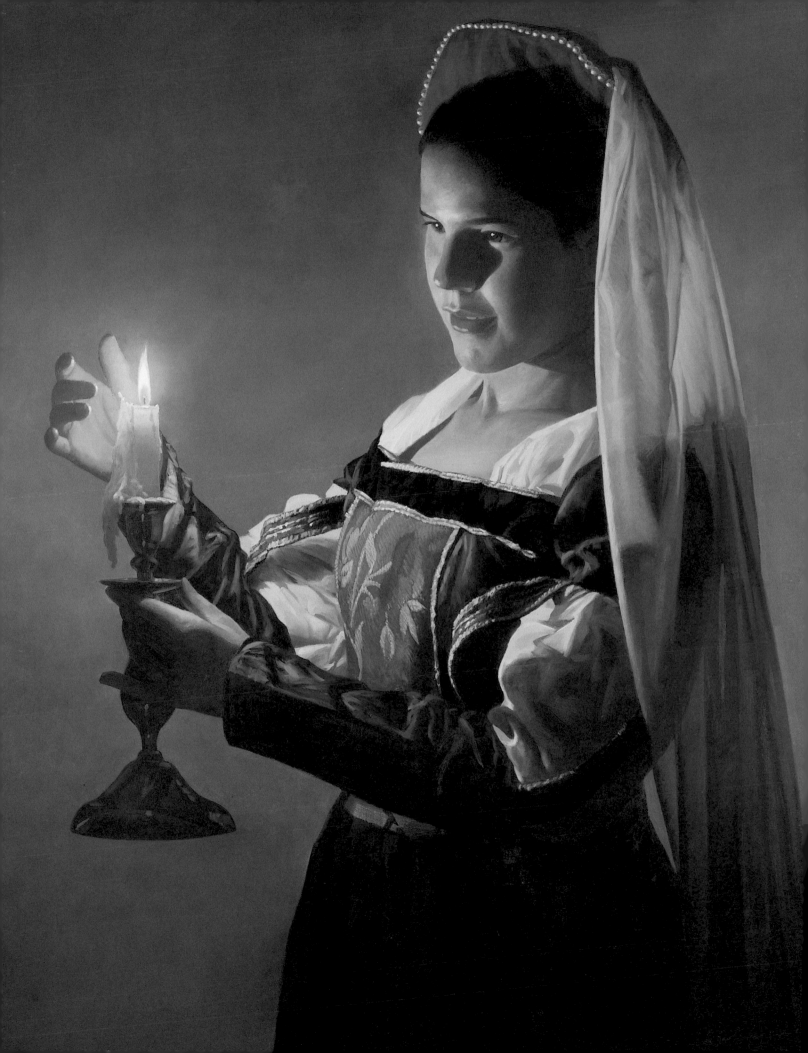

Partial Wet-into-Wet

MATERIALS LIST

Holbein Duo Aqua Oils

Base Palette
- *Burnt Sienna*
- *Cream (Naples Yellow)*
- *Light Yellow (Cadmium Yellow Light Hue)*
- *Madder*
- *Marine Blue (Phthalo Blue)*
- *Payne's Grey*
- *Raw Umber*
- *Terre Verte*
- *Titanium White*
- *Ultramarine Blue*
- *Yellow Ochre*

Accessory Palette
- *Burnt Umber*
- *Cobalt Blue*
- *Green*
- *Lemon*
- *Mars Black*
- *Navy Blue (Prussian Blue)*
- *Red*
- *Yellow (Cadmium Yellow Medium Hue)*

Mediums

Water

Winsor & Newton Artisan Water Mixable
 Linseed Oil

Brushes

Synthetic Bristles
- *Flats nos. 4–10*
- *Brights nos. 4–12*
- *Filberts nos. 4–8*

Soft Synthetics
- *Rounds nos. 1, 2 and 8*
- *Flats ¼-inch (6mm) and ½-inch (12mm)*
- *Brights ¼-inch to 1-inch (6mm–25mm)*
- *Filberts ⅛-inch to 12-inch (3mm–300mm)*

House Painting Brushes
- *1-inch (25mm) and 1½-inch (38mm)*

Fan Brush
- *White sable no. 6*

Script Liner
- *No. 4 synthetic*

Paint Shaper
- *Flat chisel no. 2 Colour Shaper*

Palette Knives

2-inch (51mm) and 1¼-inch (31mm) trowels

When you need to paint an area that smoothly shifts from one color or value to another (for example, a sky that is a medium blue at the top of the canvas and gradually lightens to very light powder blue on the horizon), the simplest approach is to lay down bands of paint that change in value and color as they progress down the canvas (or up the canvas if you are bottom-to-top minded). Then you blend the wet color bands where they meet. I call this method *partial wet-into-wet* because the blending occurs only at the meeting of the colors. It could just as aptly be called *meet in the middle*. It sure beats painting an entire area one color, then trying to gradually change the color by laboriously blending pigment into that base coat, then blending more color into the newly blended color, and then blending more. . . . You get the idea. That approach just takes so much work.

The sky in this example doesn't have a lot of shift from top to bottom, so I can get by with using only two bands of color and blending them seamlessly together. In real day-to-day painting I wouldn't be quite this orderly in my application, but for the purpose of clarity I want to keep this as straightforward as possible.

AMOUNTS OF PAINT

When I list tube pigments used to mix a new color, I list them in order of greatest proportion to least in the same fashion that ingredients are listed on grocery packages. On occasion, the colors may have all the same amount, but most of the time you can be sure the more to less progression applies.

1 | The Bottom Color

After placing the buildings and blocking them in, paint the lighter bottom color of the sky.

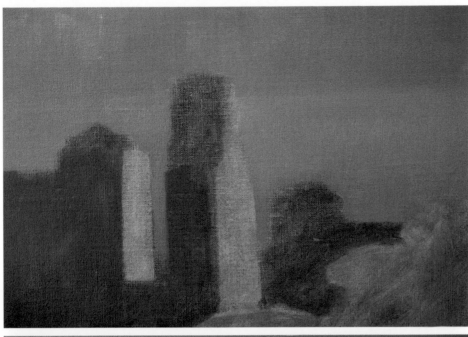

2| The Upper Sky

Mix a darker and grayer color for the top portion of the sky and paint it right up to the border of the first color.

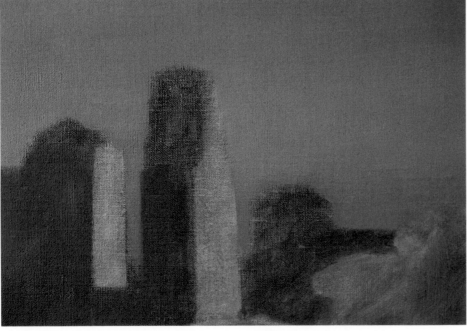

3| Blending

Use a side-to-side motion moving parallel to the meeting of the colors. Blend the two bodies of paint together, working only as far into each area as necessary to get the degree of smooth transition desired.

Transitional Colors

MATERIALS LIST

Holbein Duo Aqua Oils

Base Palette

- *Burnt Sienna*
- *Cream (Naples Yellow)*
- *Light Yellow (Cadmium Yellow Light Hue)*
- *Madder*
- *Marine Blue (Phthalo Blue)*
- *Payne's Grey*
- *Raw Umber*
- *Terre Verte*
- *Titanium White*
- *Ultramarine Blue*
- *Yellow Ochre*

Accessory Palette

- *Burnt Umber*
- *Cobalt Blue*
- *Green*
- *Lemon*
- *Mars Black*
- *Navy Blue (Prussian Blue)*
- *Red*
- *Yellow (Cadmium Yellow Medium Hue)*

Mediums

Water

Winsor & Newton Artisan Water Mixable
 Linseed Oil

Brushes

Synthetic Bristles

- *Flats nos. 4–10*
- *Brights nos. 4–12*
- *Filberts nos. 4–8*

Soft Synthetics

- *Rounds nos. 1, 2 and 8*
- *Flats ¼-inch (6mm) and ½-inch (12mm)*
- *Brights ¼-inch to 1-inch (6mm–25mm)*
- *Filberts ⅛-inch to 12-inch (3mm–300mm)*

House Painting Brushes

- *1-inch (25mm) and 1½-inch (38mm)*

Fan Brush

- *White sable no. 6*

Script Liner

- *No. 4 synthetic*

Paint Shaper

- *Flat chisel no. 2 Colour Shaper*

Palette Knives

2-inch (51mm) and 1¼-inch (31mm) trowels

Transitional colors and partial wet-into-wet blending share a common concept: In both approaches, color/value transitions are created by applying increasingly different colors one next to another. In transitional colors, though, little or no blending is done at the boundaries of colors. The illusion of shading is created in the viewer's eye by the juxtaposition of slightly different colors, not by careful blending of paint bodies.

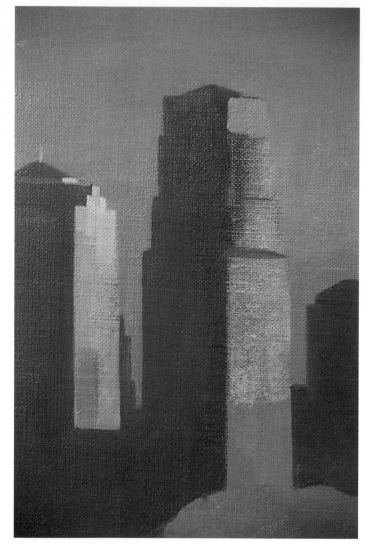

1| Paint the Darkest Value

Beginning at the bottom and top of the light side of the tallest skyscraper, paint the darkest of the reflected sky colors.

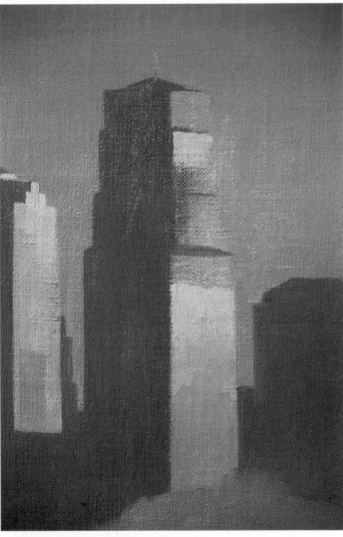

2| Apply the Next Lightest Color

Moving toward the center from both top and
bottom, mix and apply the next lighter color.

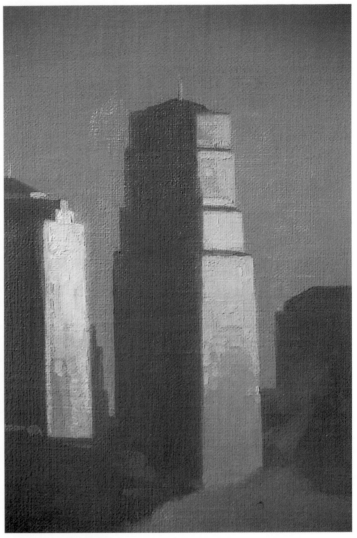

3| Brightest Value

Now add the brightest color in the midsections
of the building. You don't need to blend at the
edges of colors. The simple three-stage change
in color/value creates the effect of sunrise
reflecting from the skyscraper.

Thorough Wet-Into-Wet

MATERIALS LIST

Holbein Duo Aqua Oils

Base Palette
- Burnt Sienna
- Cream (Naples Yellow)
- Light Yellow (Cadmium Yellow Light Hue)
- Madder
- Marine Blue (Phthalo Blue)
- Payne's Grey
- Raw Umber
- Terre Verte
- Titanium White
- Ultramarine Blue
- Yellow Ochre

Accessory Palette
- Burnt Umber
- Cobalt Blue
- Green
- Lemon
- Mars Black
- Navy Blue (Prussian Blue)
- Red
- Yellow (Cadmium Yellow Medium Hue)

Mediums

Water

Winsor & Newton Artisan Water Mixable
 Linseed Oil

Brushes

Synthetic Bristles
- *Flats nos. 4–10*
- *Brights nos. 4–12*
- *Filberts nos. 4–8*

Soft Synthetics
- *Rounds nos. 1, 2 and 8*
- *Flats ¼-inch (6mm) and ½-inch (12mm)*
- *Brights ¼-inch to 1-inch (6mm–25mm)*
- *Filberts ⅛-inch to 12-inch (3mm–300mm)*

House Painting Brushes
- *1-inch (25mm) and 1½-inch (38mm)*

Fan Brush
- *White sable no. 6*

Script Liner
- *No. 4 synthetic*

Paint Shaper
- *Flat chisel no. 2 Colour Shaper*

Palette Knives

2-inch (51mm) and 1¼-inch (31mm) trowels

As the name implies, in the thorough wet-into-wet method we apply one color to an area, then blend other colors into that still-wet paint to create the shifts in color/value that are needed. This is an excellent technique to use for areas that have lots of soft color/value transitions and don't require sudden shifts from very light to very dark or vice versa. When attempting to blend a very light color into a very dark one, you inevitably pick up the wet base color and it dilutes the new color. Just imagine painting the buildings in this series of demonstrations all dark and trying to blend up to the shimmering reflections of the sunrise while still maintaining clean color. It won't work!

The steam cloud in my downtown painting is a perfect prospect for this approach. The multitude of irregular value transitions would be a headache to paint individually and blend at the edges with the partial wet-into-wet procedure.

1| Block In the Cloud

Start by blocking in the entire cloud with a medium-light slightly orangy color.

2| Blend the Dark Areas

Blend in the largest darker areas without worrying about the variations within them.

3| Blend

Blend in the smallest areas of light and dark and add the darkest darks and lightest lights.

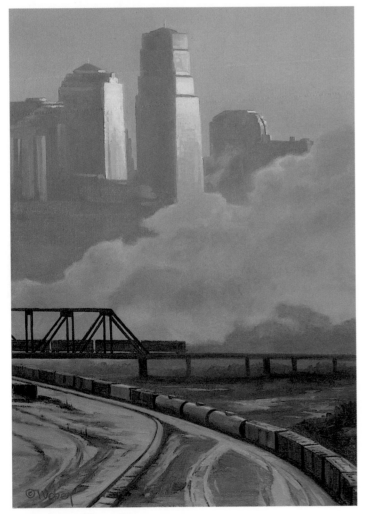

DOWNTOWN MORNING
Oil on canvas
18" × 12" (46cm × 30cm)
Collection of the artist

One Additional Bit of Information

All the details in the shadow side of the buildings were painted wet-into-wet. In some instances colors were blended carefully into the body of dark paint, and in others strokes were lightly laid on top of the base paint without blending.

Blending With Side-to-Side Pulling

Let's back up a moment to the partial wet-into-wet demonstration (page 82) I gave with the sky of *Downtown Morning*. There, I presented the overall idea; now, I want to get down to the mechanics of blending two areas of color/value into a smooth transition without going to the bother of mixing intermediate hues. The side-to-side motion I touched on in chapter two (page 34) works admirably in this situation. Start in one area of color just inside the boundary and, pulling side-to-side parallel to the meeting of the colors, advance into the second color. At the same time your brush picks up more of the color you're advancing into, it is also depositing the original color. If the first time through doesn't yield the degree of blending you want, clean your brush and start again in the first color.

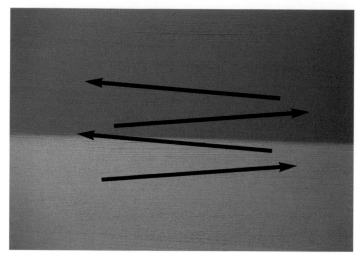

Before Blending
Lay down the two colors you intend to blend together. In practice it isn't necessary to use so clearly defined a boundary as I've used here for the sake of clarity in the demonstration.

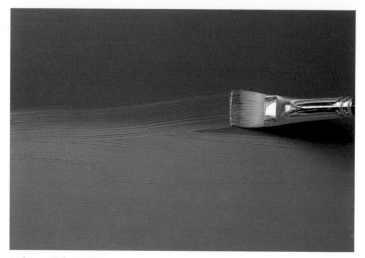

Side-to-Side Pulling
Start in one area of color just inside the boundary. As the arrows from the previous illustration suggest, pull side-to-side more or less parallel to the meeting of the colors, advancing into the second color. At the same time your brush picks up more of the color you're advancing into, it also deposits the original color. Repeat the procedure as necessary to get the degree of blending you want. If you need to repeat the blending several times, be sure to clean your brush at intervals.

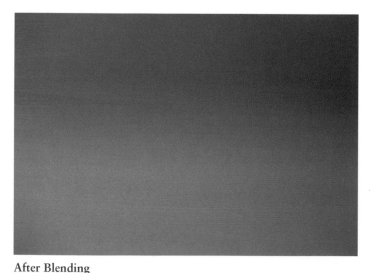

After Blending
This blending was done using only side-to-side strokes—no cheating with intermediate colors or a fan brush.

Smooth Blending

When refined blending is desired, it is necessary to master the techniques for smooth blending.

USE SOFT BRUSHES
Smooth blending requires that you set aside those vigorous bristles in favor of soft-haired brushes. The much thinner and more flexible hairs of soft brushes do not dig as deeply or coarsely into the paint you're blending and as a result leave less-visible brush marks.

USE FLATS AND BRIGHTS
Most of the time, soft flats and brights will be the best tool for smooth blending. Their straight tips enable even pressure to be exerted. Soft filberts also work well when blending with just the tip. But if you press harder to use the whole curve of the brush for smooth blending, the process becomes more difficult. Because their tips are rounded, filberts will exert uneven pressure—greater pressure in the middle, less pressure at the sides.

HOLD THE BRUSH PERPENDICULAR TO THE PAINTING SURFACE
The keys to smooth blending are control and a delicate touch. Both can be achieved through holding the brush perpendicular to the canvas. The 90-degree angle makes it possible to touch the paint with only the tips of the hairs. Since you don't have to control any other part of the brush body, you can use as light a touch as you are capable of.

AVOID PULLING UP PAINT
In some instances the brush will tend to pull up wet paint, revealing the surface below, as in the following example. This is especially likely to happen when working on a particularly smooth surface with thin-consistency paint. Assuming you can't switch to a surface with more tooth and thicker paint, you can still do a few things to minimize this tendency:
1. Use soft-haired brushes.
2. Touch very lightly at the start of the stroke.
3. Use a shallow brush-to-canvas angle, because steeply angled brush tips dig into the paint.
4. If the first three steps don't completely solve the problem, begin the strokes from the edge of the area you're painting and end them by gradually lifting up.

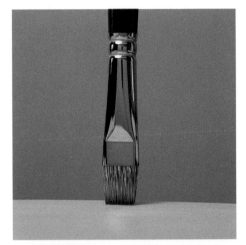

Hold the Brush Perpendicular to the Canvas
Holding the brush at the handle's end and at a 90-degree angle to the canvas makes it possible to blend with only the tips of the brush hairs. This enables you to exert the lightest pressure for maximum control in delicately blending paint.

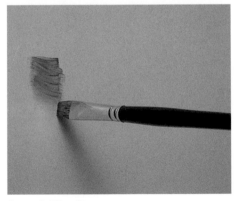

Smooth Blending
Hold the brush at approximately a 90-degree brush-to-canvas angle and touch the paint with the hair tips only. Soft-haired brights and flats work best for this careful and controlled blending on smooth surfaces.

Unintentionally Pulling up Wet Paint
Sometimes, especially when working on a smooth surface, the brush pulls up paint, revealing the surface below.

Fan Brush Blending

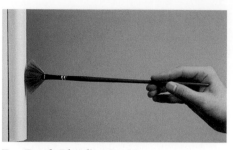

Sometimes, when you want to achieve a smooth finish exceeding even the surface smoothness described in the previous section, the fan brush (also called a feathering brush) is a valuable tool. But be careful; this tool must be used judiciously. Those who become overly dependent on fans are hampered in developing a full range of blending skills and risk having all their work coming out hazy and glass smooth. They miss out on the satisfaction and expressive power that comes with creating various brushstrokes rendered with different paint bodies.

There are two types of fans—soft and bristle—and they work in different situations. The soft-haired fans are excellent for providing a very gentle touch to smooth out brush marks and provide at best a modest amount of actual paint blending. Because their long hairs have little strength, they can't really move and blend thick paint. Bristle fans have the stiffness to blend thick paint, but they also leave very obvious brush marks. Decide what type of blending you need to do before picking out the brush.

To blend with a fan, hold the brush at its end with a pencil grip. Position it at a 90-degree brush-to-canvas angle and touch the paint surface with only the very tips of the hairs. Using finger or wrist motion, gently sweep the fan in an arc back and forth over the area you want to blend.

Fan Brush Blending Position
Hold the brush at its end with a pencil grip. It should be perpendicular to the painting surface with only the very tips of the hairs touching the paint.

Before Fan Blending
In this example the colors have been only partially blended with a flat bristle. Variations in color and brush marks are obvious.

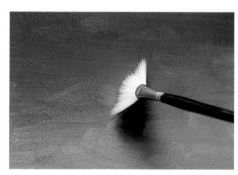

Fan Blending
Touch the paint with only the tips of the hairs. Using a finger or wrist motion, gently sweep the fan in an arc back and forth over the area to be blended.

After Blending
Using only the soft-haired fan, I've blended out the color variations and smoothed away the brush marks.

Optical Blending

In many instances it's not necessary to carefully blend pigments together. Strokes of different colors can be laid down next to each other. The farther from the picture the viewer stands, the more the colors merge in his eye. This gives you the opportunity to create works with the appearance of blending enhanced by pulsing color.

Blending With Distance: Detail
The different colors used in painting Frosty, the sky, trees and roof are evident in this detail.

Optical Blending
From a distance the varied hues blend to create transitions and flat areas pulsing with color.

The enormous snowman figure houses a slide and is placed in a park during the holiday season. The rest of the year this odd colossus is stored at a parks and recreational facility near my home.

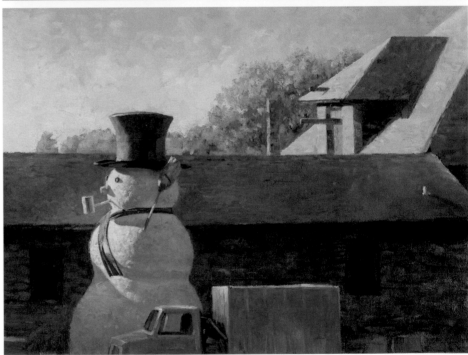

FROSTY'S SUMMER RETREAT
Oil on canvas
11" × 14" (28cm × 36cm)
Collection of the artist

Skimming One Color Over Another

MATERIALS LIST

Holbein Duo Aqua Oils
Base Palette

- *Burnt Sienna*
- *Cream (Naples Yellow)*
- *Light Yellow (Cadmium Yellow Light Hue)*
- *Madder*
- *Marine Blue (Phthalo Blue)*
- *Payne's Grey*
- *Raw Umber*
- *Terre Verte*
- *Titanium White*
- *Ultramarine Blue*
- *Yellow Ochre*

Mediums

Water
Winsor & Newton Artisan Water Mixable
 Linseed Oil

Brushes

Synthetic Bristles

- *Flats nos. 4–10*
- *Brights nos. 4–12*
- *Filberts nos. 4–8*

Soft Synthetics

- *Rounds nos. 1, 2 and 8*
- *Flats ¼-inch (6mm) and ½-inch (12mm)*
- *Brights ¼-inch to 1-inch (6mm–25mm)*
- *Filberts ⅛-inch to 12-inch (3mm–300mm)*

With the skimming technique, first lay one color down over an area; take care to cover the low spots of the surface texture. Then, holding the brush at a very low brush-to-canvas angle, skim another color over the canvas so that primarily the peaks of the texture are coated but the original color in the valleys remains visible. Just as in the previous section, given adequate distance the viewer's eye tends to blend the closely occurring colors together.

It's also possible to create your own texture by making thick brush marks with your first layer of paint. When that has dried, you skim over the tops of those newly generated peaks, allowing the valley color to show through.

As you can guess, skimming has applications beyond blending. The respective colors of the peaks and valleys can be pushed to all sorts of extremes and variations to create irregular patterns in foliage, rippling water, fabric, splotchy complexions (not recommended for commission portraits) and abstract painting.

In many instances this technique could also be termed *dry-brush*, but for purposes of clarity I'm going to stick with the more self-explanatory term *skimming*. Also, dry-brush implies using paint that is thinned with little or no medium. Skimming as I intend it can be accomplished with or without thinning agents.

In the following example I've exaggerated the color difference between valleys and peaks so that they show up adequately. But your color modulations can become as subtle as you like in blending this way.

Skimming One Color Over Another
In this illustration, the brush, held at a very low brush-to-canvas angle, lightly skims over the exaggerated weave, depositing yellow paint only on the peaks. The green in the valleys is allowed to show through.

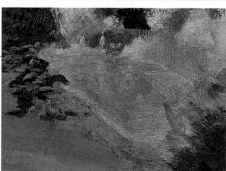

1 | Before Skimming

Quickly wash in a base color that you want to show through in places. Make sure the paint is worked into all the valleys of the surface tooth. Here, I've used a bright red on a medium-coarse linen with added texture. You can wait for the base wash to dry or proceed right after applying it.

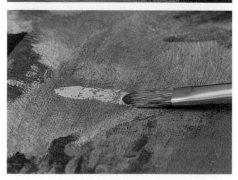

2 | Skimming Application

Using the tip-pull-loading method with a no. 8 bristle flat, pick up a thin to medium-thick load of paint on the brush, then, using a very shallow brush-to-canvas angle, lightly pull the brush over the canvas. The paint will land on the peaks of the weave but will leave much of the color in the low spots showing.

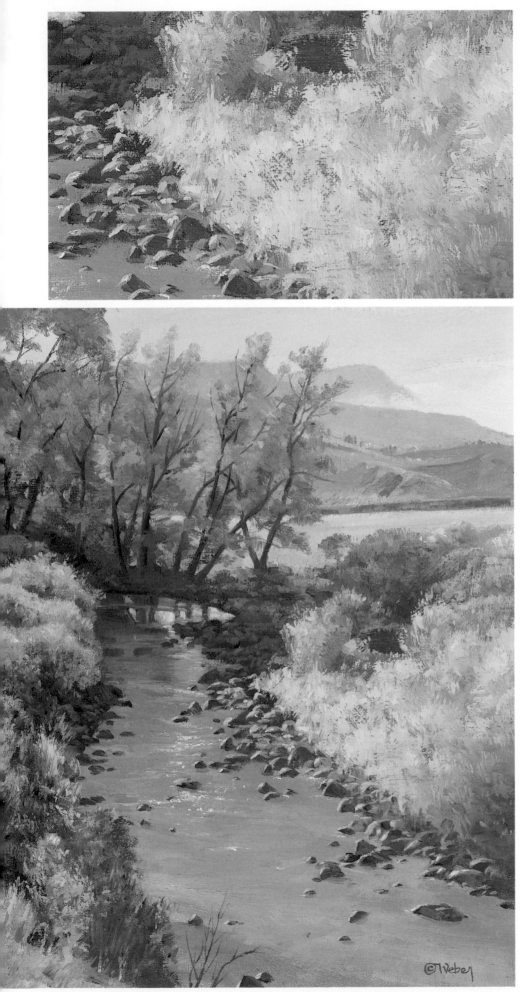

Painting Detail

Even though I've worked over the area of yellow growth with several yellows and greens, the original red I laid down shows through. When viewed from a distance the smaller areas of red are blended by the eye and actually appear orange. The larger areas still show red, adding to the rich display of fall colors.

COLORADO GOLD
Oil on textured linen
18" × 14" (46cm × 36cm)
Collection of the artist

Glazing and Scumbling

In skimming, one could choose to work wet-into-wet or wet-into-dry, depending on what works best for the particular task. But with glazing and scumbling we are dealing with strictly wet-into-dry blending techniques. Both involve painting thin layers of translucent colors over dry paint to alter rather than completely block out the bottom color.

GLAZING

In the case of glazing, a translucent darker color is applied over a lighter base color with the glaze acting as a tint.

Why glaze? When pigments are mixed with white to lighten them, the white decreases their intensity and causes them to become a bit gray. In instances where you need to lighten the value of a color without losing its brilliance, glazing is just the ticket. It enables you to make much more intense colors than you can mix. Glazing is also very handy for adjusting colors you didn't get right the first time.

SCUMBLING

With scumbling, a coat of translucent lighter paint is applied over a darker ground color that is dry. At times it's very helpful to lighten a dry color without covering it with an opaque coat of paint.

Both glazing and scumbling can be accomplished with anything from pigment straight from the tube to very thin-consistency paint.

BLENDING WITH GLAZING AND SCUMBLING

Paint a glaze over a light area and gradually thin it as you progress to create a subtly graduated tone. Do the reverse for scumbling: light over dark.

Glazing
I've painted a thin, translucent glaze of Phthalo Blue over dry bands of white, yellow and red. It's simply impossible to achieve a light blue this intense by mixing white with any blue. Observe how bright a green is generated by glazing the blue over bright yellow.

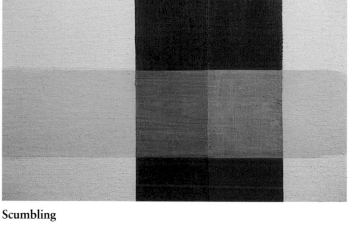

Scumbling
Painting a thin, translucent scumble of Yellow over dry bands of blue and red lightens and changes the colors but makes less-intense hues than glazing.

Using Paint Layers to Create Depth

Some colors, being inherently more translucent, are more suitable for glazing than others. Earth colors have minimal tinting strength, while others, like Ultramarine Blue, Rose Madder and the Phthalo colors, are excellent for glazing.

Glazes and scumbles can be applied in relatively deep layers of juicy pigment, or thin washes, or rubbed on with a rag. Make sure the base colors are perfectly dry or the bottom color will lift up and muddy the glaze. But remember, the more additives you mix into your paint and the more layers of paint you add, the greater the risk you run of the paint film cracking, flaking, yellowing or darkening.

One important factor to take into account when glazing and scumbling with relatively fluid paint is the degree of surface texture. Any surface with moderate to heavy texture will cause the fluid paint to run down into the valleys of the tooth and create puddles of thicker paint as soon as you turn your back. With glazes, this will result in pools of dark, and scumbles will make light puddles. If you plan on glazing and want to avoid this, it's best to use a smooth surface. Sometimes, however, this can intentionally be used to your advantage to create irregular pools of translucent pigment for texture or other effects.

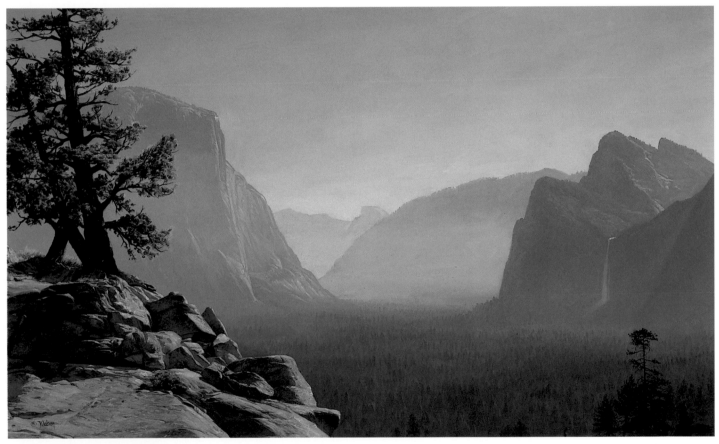

Before Glazing and Scumbling
When I finished this painting, it just seemed to lack something. (All right! It was boring: Everything was too gray.) I wanted to make changes but without doing extensive repainting.

Glazing Over the Rocks

To make the foreground rocks warmer, I used a no. 10 bristle bright to apply a no. 4 consistency glaze of Burnt Umber with Cream and a touch of Ultramarine Blue. The Cream lightens the mixture while maintaining its warmth.

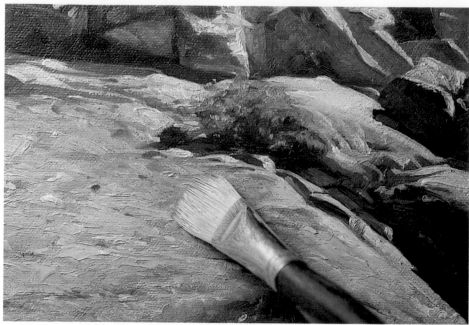

Scumbling in Haze

Breaking up the lines of the mountains without entirely obscuring them reduces the lumpy monotony of their shapes. I scumbled on patches of mist, using a mixture of Titanium White with a bit of Payne's Grey and Ultramarine Blue, with a no. 8 bristle bright.

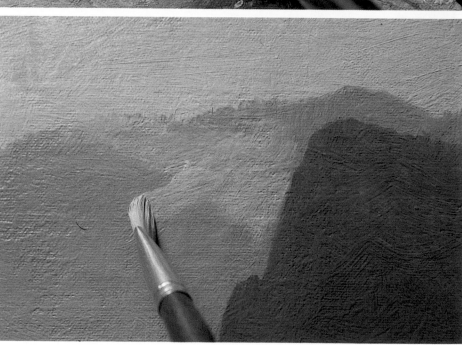

After Glazing and Scumbling

Intensifying the blue of the sky will combat the dull gray tone of the picture. I mixed a no. 3 consistency glaze of Ultramarine Blue, Cobalt Blue and Titanium White. I started at the top and gradually spread it more thinly as I worked downward so as to leave the lower sky lighter. I heightened the color in the tree trunks and added a few clouds to the upper sky and a few flowers to the foreground. All these subtle changes make for a more visually stimulating painting.

Rendering Careful Detail

Painting fine-detail pictures employs the same basic principles and techniques
as many of the methods already covered, but we use these principles and
techniques in a more refined fashion and with only a small number of additions.

Keep It Steady

BRUSHES

For starters we use the same types of brushes to paint fine details as we use for less-detailed work, but we choose brushes with smaller bodies and much finer points than their standard brothers. The rounds especially can range down to the minuscule 0000 size and even smaller.

GRIP

The pencil grip with fingers positioned on or near the ferrule provides the greatest degree of control, making it the grip of choice for close, careful work.

HAND SUPPORT

Since maximum control is essential for close detail work, it is often necessary to provide additional support to steady the brush-wielding hand. Two hand-steadying techniques are available. The first is simply extending your little finger to use it as a ready-made support strut.

MAHLSTICK

However, if the area you're working on is surrounded by a lot of wet paint, you stand a good chance of sticking your pinkie in it. Plan B is the mahlstick, which is an approximately three-foot-long piece of dowel topped with a knob of some sort. I made my own and covered the knob with smooth leather. Much of the time the mahlstick's tip is braced at the painting's edge, but larger pictures require that the knob often be rested on the dried paint of the picture. I've found that leather is the least likely material to leave marks on the dried paint. Other tip materials such as rubber, plastic and wood leave marks of various kinds.

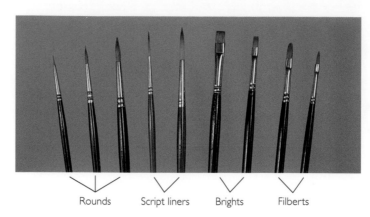

Brushes for Careful Detail
Note the small bodies and tips of these brushes.

Rounds Script liners Brights Filberts

Steadying Hand With Little Finger
Place the little finger on a dry section of the painting to lend support to the brush hand.

Using a Mahlstick
Rest your brush hand on the mahlstick to provide maximum steadying for the brush while painting.

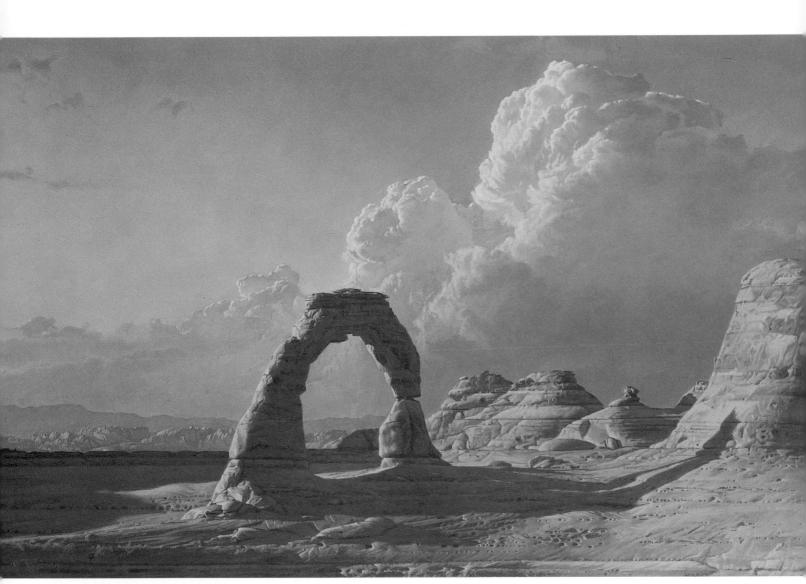

Use a Mahlstick for Careful Detail

I used a mahlstick to steady my painting hand while carefully render-
ing all the detail of the entire foreground of this painting. With the
hand resting on the stick, any unsteadiness from your waist through
your shoulder and your arm to your wrist is eliminated at the stick.
Maximum muscle control is needed only for the fingers. (Unless
you've got something crawling up your leg, which is a problem I'll
deal with in my next book: Painting on Location Near the Great
Roach Pits of the Amazon Basin.*)*

TEXTURES OF THE EARTH
Oil on panel
20" × 30" (51cm × 76cm)
Private collection

Using a Script Liner

The script liner, or rigger, is specially designed for painting long thin lines such as branches, fence wire and ship rigging. Its elongated, flimsy body can soak up a large amount of very thin-consistency paint, then dispense it in long flowing strokes through the fine point. It is loaded by using the body fill-up method. The script liner's long hairs make it unsuitable for manipulating thick-consistency paint.

Painting a Branch With a Script Liner
Use the body fill-up method to soak up no. 6 or 7 thin-consistency paint. Then using just the very point of the brush, paint long, thin flowing lines.

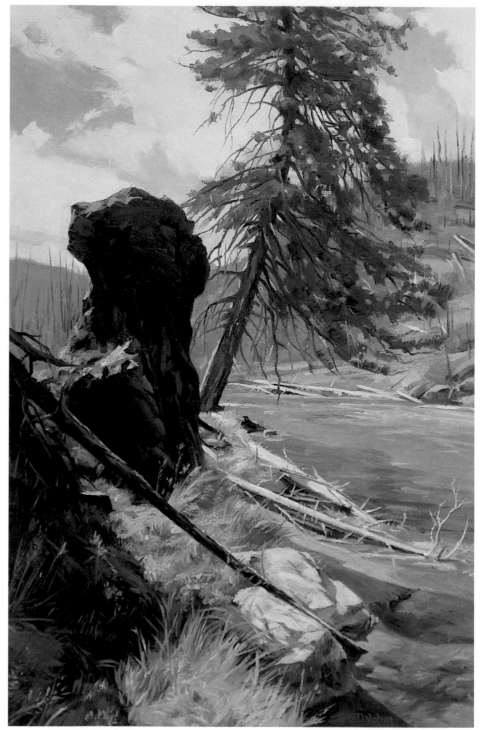

Script Liner Strokes
All of the branches were painted using a script liner. The straight strokes of the distant burned tree trunks and much of the grass were painted employing the chisel-tip/shovel-loading method with a ½-inch (12mm) soft-haired flat.

RIVERSIDE—YELLOWSTONE
Oil on linen
18" × 12" (46cm × 30cm)
Collection of the artist

Point Loading a Round

Often in detail painting it's necessary to paint very small highlights; rounds are the perfect tools for this type of work. To carry this out, first shape the brush to as fine a point as it will take, then lower the point into the paint pile, picking up only as much pigment as is needed. Touch only the paint; don't push through to the palette because that will force apart the hairs and blunt the point. Finally, apply the paint to the canvas, being careful to touch with only the paint rather than with the brush. Script liners can also be used for this technique although thinner paint must be employed.

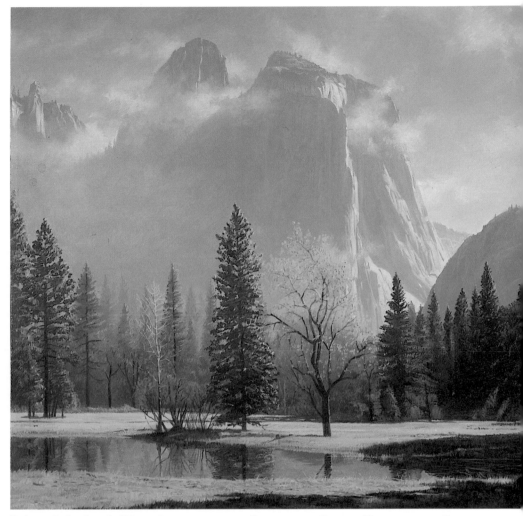

Point Loading a Round
Shape the brush to a fine point, then dip only the very tip into the paint pile. Load only as much pigment as you need for the highlight you're about to paint.

Using a Point-Loaded Round
The trees, grass and highlights on the rock formations required a good deal of careful work with rounds using the point-loading technique to render the fine detail.

CATHEDRAL ROCK—HEAD IN THE CLOUDS
Oil on panel
14" × 14" (36cm × 36cm)
Collection of John Weil

Rendering Careful Detail

MATERIALS LIST

Holbein Duo Aqua Oils

Base Palette
- *Burnt Sienna*
- *Cream (Naples Yellow)*
- *Light Yellow (Cadmium Yellow Light Hue)*
- *Madder*
- *Marine Blue (Phthalo Blue)*
- *Payne's Grey*
- *Raw Umber*
- *Terre Verte*
- *Titanium White*
- *Ultramarine Blue*
- *Yellow Ochre*

Accessory Palette
- *Burnt Umber*
- *Cobalt Blue*
- *Green*
- *Lemon*
- *Mars Black*
- *Navy Blue (Prussian Blue)*
- *Red*
- *Yellow (Cadmium Yellow Medium Hue)*

Mediums

Water

Winsor & Newton Artisan Water Mixable
 Linseed Oil

Brushes

Synthetic Bristles
- *Flats nos. 4–10*
- *Brights nos. 4–12*
- *Filberts nos. 4–8*

Soft Synthetics
- *Rounds nos. 1, 2 and 8*
- *Flats ¼-inch (6mm) and ½-inch (12mm)*
- *Brights ¼-inch to 1-inch (6mm–25mm)*
- *Filberts ⅛-inch to 12-inch (3mm–300mm)*

House Painting Brushes
- *1-inch (25mm) and 1½-inch (38mm)*

Fan Brush
- *White sable no. 6*

Script Liner
- *No. 4 synthetic*

Paint Shaper
- *Flat chisel no. 2 Colour Shaper*

Palette Knives

2-inch (51mm) and 1¼-inch (31mm) trowels

Mahlstick

This section jumps ahead a bit to the next chapter, but I wanted to show how painting the final details fits into the development of a painting, before we go into the entire process. I worked wet-into-wet for everything but a few touch-ups in the picture.

1 | Block-in Stage

Since the details fit into the overall framework of the picture, it's important to block in the basic shapes of color and light and dark and place things as accurately as possible. Scrub and wash in this stage with nos. 6, 8 and 10 bristle brights and flats. For the flowers use a no. 6 consistency mixture of Titanium White and Madder for the most part but with some Ultramarine Blue and a touch of Payne's Grey added in the cooler areas. Add Burnt Sienna and Payne's Grey to create the darker color of the background flowers. Make the background wash for the leaf area from Terre Verte and Raw Umber. Use an Ultramarine Blue wash for the upper right corner.

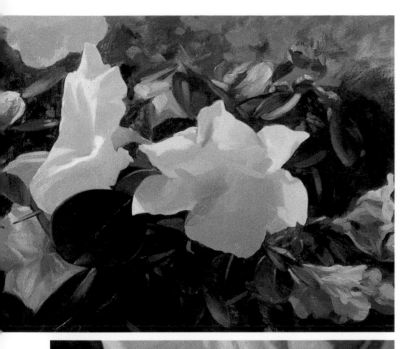

2 | Paint Intermediate Shapes

For all of this stage, use nos. 1 and 2 consistency paint. Before moving ahead on the main flowers, loosely paint in the background to near completion. For the darkest greens, use a mixture of Terre Verte darkened with Ultramarine Blue and Raw Umber. The leaf areas lit by direct sunlight need a good deal of Yellow mixed in with Terre Verte and Titanium White or Cream. For the leaves lit by reflected light, add Ultramarine Blue with Titanium White. Do most of this work using the tip-pull-loading method for thick short strokes. Now tackle the two main flowers with a ¼-inch (6mm) soft flat to model the variations in the shadows and light areas. Use the soft brush tip to carefully blend the edges of areas. Employ the same colors as in the block-in stage with the addition of Yellow Ochre mixed with Cream and a touch of Raw Umber for the center of the right main blossom.

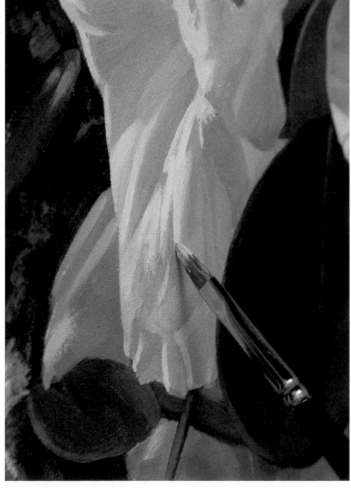

3 | Paint the Details

Paint the thin highlights in the left flower using a ⅛-inch (3mm) soft filbert and no. 3 consistency paint—a mixture of Titanium White with a touch of Madder. Steady your hand using the mahlstick.

4 | Refining More Details

Work carefully and methodically in the shadows of the right flower to define the darks and lights that create the petal texture, including the red streaks and the darker yellow area in the flower's center. For the brightest parts in the yellow center, add Light Yellow to Titanium White. Complete the highlights, in some spots applying thicker strokes to catch the light.

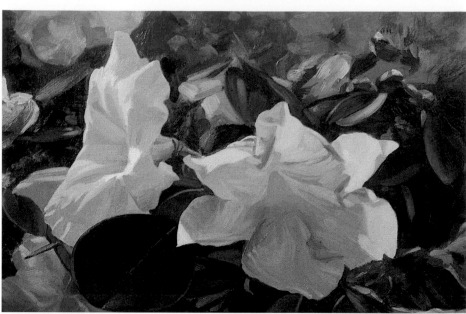

Close-Up

Compare the carefully rendered details in this close-up to the intermediate stage. When doing detail work, I usually enjoy the final stage the most of all because the painting practically crackles with intensity as it reaches crystal clarity.

PINK BLOSSOMS
Oil on canvas
11" × 14" (28cm × 36cm)
Collection of the artist

7 | Using Brushstrokes for Great Results in Your Paintings

After all the in-depth technical instruction we've worked through, I'll bet you're as eager as I am to start using these new brushstroke methods in some real-life paintings. This is the chapter where we do that, but I have just one more little thing I want to talk about before we cut loose.

You can't have helped but notice that I use strong light effects to create a sense of drama in my paintings. Let me walk you through the basic principles of painting realistic light effects to help you better understand vision and learn to analyze what you see. And then we'll do some real painting; I promise.

YOSEMITE TRANQUIL
Oil on canvas
30" × 18" (76cm × 46cm)
Collection of Dewey, Ballantine, LLP

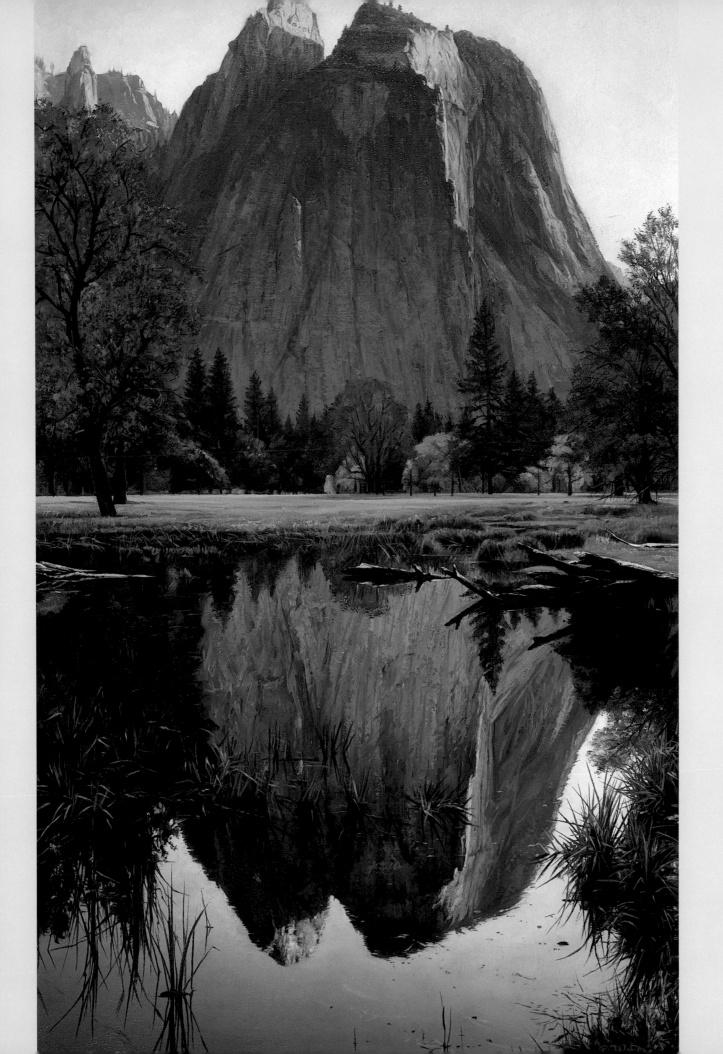

Painting Realistic Light Effects

For quite a while we've been totally immersed in all sorts of brushwork minutia. Now it's time to come up for a deep breath and take a look at the bigger picture. All the proper brushstroke techniques we've covered up to this point are simply the mechanical bits and pieces that make the painting process as easy, skillful and expressive as possible. But how do you take that knowledge and use it to craft a realistic painting?

Look at the world around you and what do you see? Amazing, mind-boggling wonders woven from an impossibly complex fabric of shapes, colors and compositions, trimmed with profound psychological, spiritual and emotional depths, and all begging to be shared with others through art?

Well, yes and no. While all of those things and more are before our eyes, what we actually see are simply patterns of color and light and dark. Allow me to explain.

Light from different sources is continually zinging and zapping about, striking some objects and being partially or fully absorbed, passing through others, reflecting, glaring, filtering through atmosphere and finally reaching our eyes. Our lenses focus this jumble of photons onto the light-sensing cells of our retinas at the backs of our eyes. Nerves carry the information to our brains, which interpret everything and make sense of it. Talk about mind-boggling!

The key to grasp here is that the all-important retina, which receives the focused light, is a *flat* surface. True, it is a curved flat surface, but flat nonetheless. Through the marvel of parallax vision (two eyes viewing everything from slightly different locations to create depth perception) and the incredible interpretive power of our brains, we perceive the world as three-dimensional. But that sense of depth and solidity is all extrapolated from the flat images on our retinas.

The implication for painting is crucial. Since our brains are dealing with visual information from a *flat* surface, it's possible to reproduce the light patterns from our retinas on a *flat* canvas. If we give the same visual information to the eyes of others, their brains will interpret it as being real, or nearly so.

To render things realistically you must first train your brain to recognize that your eyes have already reduced the visual world to two dimensions. Once you have discarded that pesky third dimension and are working with only two, you can begin to analyze your retinal images, breaking things down into patterns of color and light and dark. In a way you train your

Defining Shape and Value
In this photograph I've drawn a red line around the basic light areas and a blue line around the basic dark areas.

CHURCHYARD STILE
Oil on linen
20" × 16" (51cm × 41cm)
Collection of David and Nancy Stump

mind to think like a paint-by-numbers set, but all the lines and colors are in your head.

First, you learn to see the very largest and most obvious shapes of color and light and dark. Don't even think about all the detail and nuances of color and shading. A trick that aids in seeing only the basic shapes is to close one eye and cause the open eye to be out of focus when looking at the subject. Or you can squint to put your eyes out of focus. These techniques eliminate detail and make the relative values and colors of the large areas easier to determine. In the photograph I've drawn a red line around the basic light areas and a green line around the basic dark areas.

Once you've got the basic areas drawn or painted in proper relationship to one another, look to the next smaller areas within the largest areas. Paint those, then discover and paint the next smaller areas.

These principles are the mental framework I use to guide me in painting a realistic image. Keeping them in mind as you work your way through the step-by-step demonstrations is absolutely essential to understanding my method. Before painting what you see, you must learn to visually analyze what is before you.

Don't think of these demonstrations as merely painting exercises. View them first of all as exercises in observation. Observe and analyze first, paint second. If you're the type of person who paints first and asks questions later—you're just so eager to start mooshing that paint around on the canvas—this may be difficult at first. But believe me, you can't paint what you don't clearly see.

As a first step with each demonstration, think through the visual analysis that is needed at each stage before touching brush to paint.

You can see that in the first step I begin by observing and painting the largest and most general shapes. In each succeeding step I observe and paint progressively smaller shapes until I've completed the last detail.

Once you understand how the paint must be arranged to reproduce the image you're seeing, then all the brushstroke techniques we've covered in the previous chapters come into play. You use this loading method and that application technique to arrange the paint in a particular way. The types of brushstrokes you use fit into the overall framework of the painting.

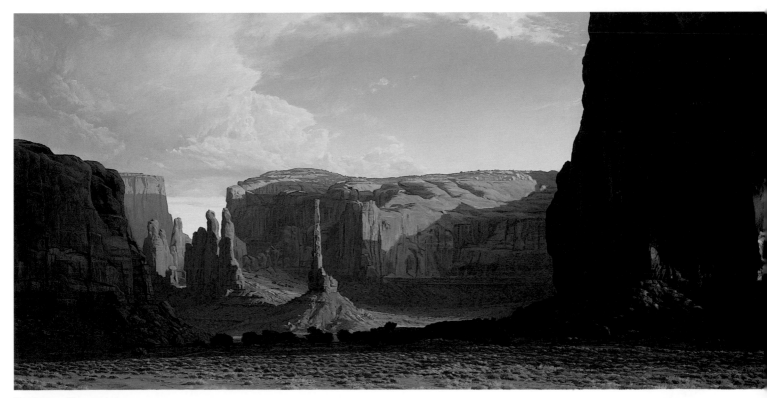

DISTANT GATHERING
Oil on canvas
17" × 36" (43cm × 91cm)
Private collection

MATERIALS LIST

Holbein Duo Aqua Oils
Base Palette
- *Burnt Sienna*
- *Cream (Naples Yellow)*
- *Light Yellow (Cadmium Yellow Light Hue)*
- *Madder*
- *Marine Blue (Phthalo Blue)*
- *Payne's Grey*
- *Raw Umber*
- *Terre Verte*
- *Titanium White*
- *Ultramarine Blue*
- *Yellow Ochre*

Accessory Palette
- *Burnt Umber*
- *Cobalt Blue*
- *Green*
- *Lemon*
- *Mars Black*
- *Navy Blue (Prussian Blue)*
- *Red*
- *Yellow (Cadmium Yellow Medium Hue)*

Mediums
Water
Winsor & Newton Artisan Water Mixable
 Linseed Oil

Brushes
Synthetic Bristles
- *Flats nos. 4–10*
- *Brights nos. 4–12*
- *Filberts nos. 4–8*

Soft Synthetics
- *Rounds nos. 1, 2 and 8*
- *Flats ¼-inch (6mm) and ½-inch (12mm)*
- *Brights ¼-inch to 1-inch (6mm–25mm)*
- *Filberts ⅛-inch to 12-inch (3mm–300mm)*

House Painting Brushes
- *1-inch (25mm) and 1½-inch (38mm)*

Fan Brush
- *White sable no. 6*

Script Liner
- *No. 4 synthetic*

Paint Shaper
- *Flat chisel no. 2 Colour Shaper*

Palette Knives
2-inch (51mm) and 1¼-inch (31mm) trowels

Mahlstick

You can begin a painting in a variety of ways:
- Pencil in the image on your support.
- Draw on paper and trace the drawing onto your support.
- Do a preparatory drawing on gridded paper; then, with the aid of a grid system on the canvas, enlarge and draw the image onto it.
- Start painting detail from the very beginning.
- Sketch in basic shapes with a small to medium brush using thinned paint.
- Scrub and block in the major areas with a large brush.

Though I've used all of these methods at one time or other, now I usually do a combination of the last two, drawing in with a small to medium filbert or bright and washing in whatever areas I need to determine how the composition is shaping up.

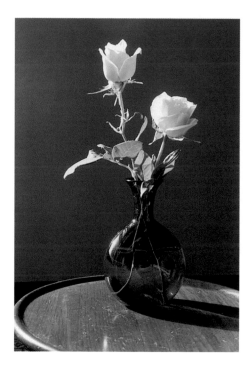

Reference Photo
Until you master the mental and visual skills of seeing things in two dimensions, one of the most challenging things to paint is glass. The first step in conquering glass is to avoid thinking of it as a transparent three-dimensional object. Instead look at the patterns of color and light and dark that make it up. There's no special "glass technique." If you simply paint the patterns of color and light and dark as they appear on your retina, your picture will look like glass.

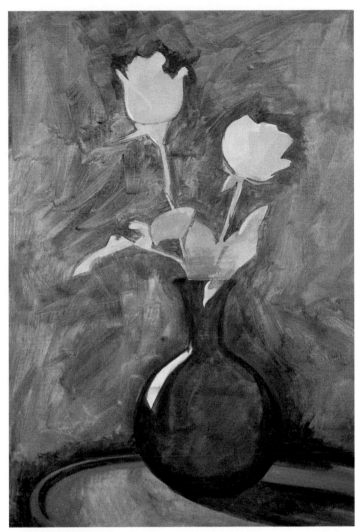

1 | Sketch the Basic Shapes

Using a worn ⅜-inch (10mm) soft bright, begin by sketching the big shapes and establishing the placement of objects. Place and draw things as accurately as possible to save the trouble of adjusting them later when it's more difficult. Now is the best time to rub out an incorrect section and move it where it belongs. If the large shapes are painted in correct relationship to one another, it's much easier to place the smaller shapes in the proper places in subsequent stages.

Use a no. 7 consistency mixture of Madder with a bit of Ultramarine Blue for the vase. Use Madder and Raw Umber for the table. Raw Umber is used to sketch in the flowers and leaves. Try a wash of Lemon and Terre Verte for the leaves and a Light Yellow and Yellow Ochre wash for the flowers. Use the body fill-up method to saturate the brush with the thin-consistency pigment for all the sketching.

2 | Apply a Wash and Block In the Painting

The objective at this stage is two-fold: Apply a wash to nearly everything to see how the overall composition looks before laying in thick paint; and block in the basic areas of color, light and dark. Using nos. 10 and 12 bristle brights and no. 6 consistency paint, wash and scrub in the background with a mixture of Raw Umber and Ultramarine Blue with a dash of Burnt Sienna in spots. The body fill-up makes it possible to carry lots of thin paint in the brush and makes quick work of all the washes.

For the flowers, leaves and stems, first apply a wash with nos. 6 and 8 bristle flats, then block them in with opaque paint, delineating the dark, light and intermediate colors. The colors here are Titanium White and Yellow for the flowers, and Terre Verte with Lemon and Titanium White for the leaves and stems, adding a bit of Ultramarine Blue in the shadows. Madder is purpled up a bit with some Ultramarine Blue for the vase's wash. Paint the table with Burnt Sienna and Raw Umber. Use brights to block in. Tip load and apply the paint at a medium to steep angle. Eliminate some leaves because they clutter the composition.

3 | Paint the Background and the Intermediate Shapes in the Roses and Leaves

At this stage you want to get everything as accurate and clearly delineated as possible. First, paint the background a mixture of Raw Umber, Ultramarine Blue, Cream and Titanium White, with a 1-inch (25mm) soft bright, and carefully paint up to and around the foreground objects with a ¼-inch (6mm) soft bright.

Paint the intermediate colors, lights and darks of the roses, stems and leaves with opaque pigment. Work with ¼-inch (6mm) soft brights, flats and filberts. For light areas of the flowers use Light Yellow, Titanium White and Cream. In the shadows mix Yellow, Yellow Ochre and Burnt Sienna; add Madder in the redder shadows. The colors for the leaves are the usual Terre Verte lightened with Cream and in some spots cooled with Ultramarine Blue. The areas where light shines through the leaves are mixed from Lemon and Green. The thorns have a bit of Burnt Sienna with Cream in them. Use nos. 1 and 2 consistency paint for everything until the final detail and glazing.

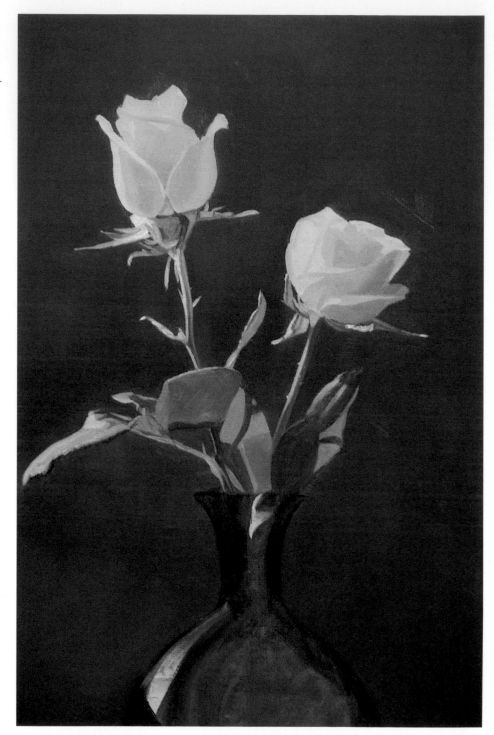

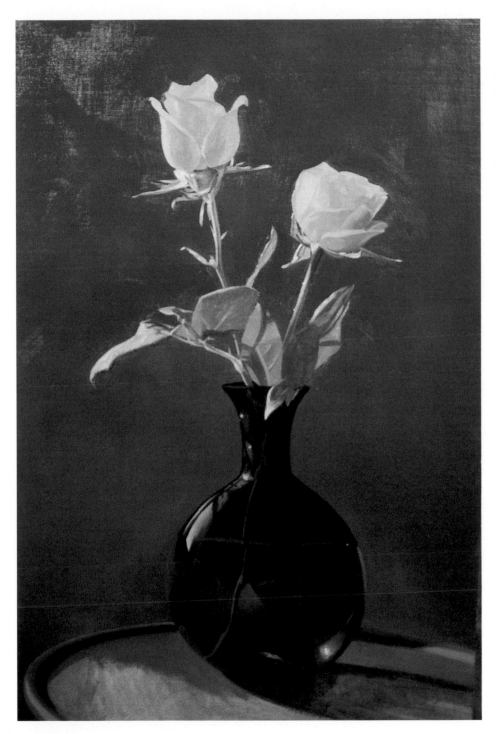

4 | Paint the Intermediate Shapes in the Vase

Go through the same process of painting the intermediate shapes and colors using the same paint consistency as in step three. However, in the darker parts the vase has larger areas requiring careful partial and thorough wet-into-wet blending, so use a ⅝-inch (16mm) soft bright, which will leave fewer brush marks and require less work than smaller brushes. For the clearer and smaller shapes, stick with the ¼-inch (6mm) soft brights, flats and filberts you used for the roses. The larger areas can be accomplished with tip pull loading and the small, more precise section with chisel tip loading. For the dark areas use the same combination of Madder and Ultramarine Blue as in the wash-in stage. The redder shapes in the middle of the vase require Burnt Sienna and Red in place of the blue.

In the lightest areas of the stems and thorns use a mixture of Light Yellow, Yellow Ochre and Madder. Surrounded by so much purple, red and violet, this color will appear somewhat greenish. Work with a ¼-inch (6mm) soft flat for the stems and a ¼-inch (6mm) or smaller soft filbert for the thorns.

On the left side of the vase the lightest reflections begin with Titanium White and Ultramarine Blue blended at the edges into the deep purple. Then blend Titanium White with the slightest touch of Ultramarine Blue for the brightest highlights. Tip load the pigment; use a ¼-inch (6mm) soft flat or filbert to stroke the paint somewhat thickly onto the previous color without blending so that the brightest reflection stands up and catches more light.

At the bottom of the vase and in its neck are a few areas where the light glows through the richly colored glass, creating strongly tinted hues. To capture that color with glazes, it's necessary to plan ahead. Because the glaze will darken the areas, mix Titanium White with Madder—no medium added—and, with a ¼-inch (6mm) soft bright, paint them considerably lighter than they will end up. Do not attempt glazing until this bottom paint is thoroughly dry.

5 | Paint the Fine Detail With a Pointed Round

Point load a minuscule dab of paint on the very tip of a no. 8 soft round. Supporting your hand with a mahlstick, touch only the paint to the canvas to render the thorn.

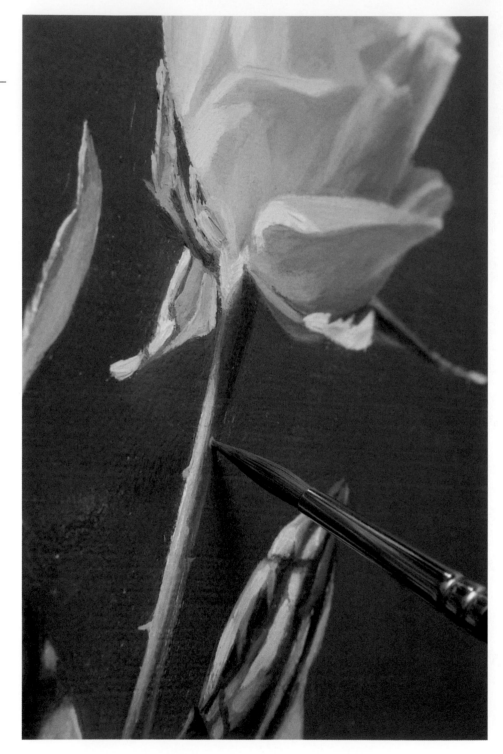

6 | Final Details and Glazes

Usually this stage is the most fun. Once all the major and intermediate shapes are properly placed and related, you get to play to your heart's content with the finer brushes moving the paint around, and things begin dramatically popping to life. Because the pigment needs to flow more smoothly at this point, thin it to no. 4 consistency, with the exception of a few highlights that you want to stand up and catch the light. For these use undiluted paint. Chisel the tips of ¼-inch (6mm) and ⅝-inch (16mm) soft brights and filberts and pick up the paint with the chisel-tip-loading technique to do nearly all the linear work in the flower highlights, stems and leaves and narrow vase reflections. Work with the brushes at a steep angle. Using nos. 1 and 8 soft rounds, render the small final details. The colors used are the same as have been noted earlier, with the exception of a few bluish reflections in the vase. Mix Ultramarine Blue, Payne's Grey and Titanium White with just a bit of Madder to get this color.

To capture the delicious purple glow in the base and neck of the vase, glaze a no. 5 consistency combination of Madder and a little Ultramarine Blue over the areas you purposely painted too light and that are now dry. Absolutely do not add white to the glazing mixture since that would gray the color. The light color you glaze over will provide all the brightness you need.

The background is too plain, so scumble around on it to create a bit of color variation to slightly lighten parts of the background and subtly break it up.

Paint the table with various combinations of Burnt Sienna, Cream, Raw Umber and Titanium White. Use a glaze of Madder to create the brightest reds in the vase shadow. Titanium White, Cream and Yellow are the colors to use for highlights on the table's edges.

YELLOW ROSES AND PURPLE VASE
Oil on canvas
24" × 16" (61cm × 41cm)
Collection of David and Nancy Tillson

MATERIALS LIST

Holbein Duo Aqua Oils
Base Palette
- *Burnt Sienna*
- *Cream (Naples Yellow)*
- *Light Yellow (Cadmium Yellow Light Hue)*
- *Madder*
- *Marine Blue (Phthalo Blue)*
- *Payne's Grey*
- *Raw Umber*
- *Terre Verte*
- *Titanium White*
- *Ultramarine Blue*
- *Yellow Ochre*

Accessory Palette
- *Burnt Umber*
- *Cobalt Blue*
- *Green*
- *Lemon*
- *Mars Black*
- *Navy Blue (Prussian Blue)*
- *Red*
- *Yellow (Cadmium Yellow Medium Hue)*

Mediums
Water

Winsor & Newton Artisan Water Mixable
 Linseed Oil

Brushes
Synthetic Bristles
- *Flats nos. 4–10*
- *Brights nos. 4–12*
- *Filberts nos. 4–8*

Soft Synthetics
- *Rounds nos. 1, 2 and 8*
- *Flats ¼-inch (6mm) and ½-inch (12mm)*
- *Brights ¼-inch to 1-inch (6mm–25mm)*
- *Filberts ⅛-inch to 12-inch (3mm–300mm)*

House Painting Brushes
- *1-inch (25mm) and 1½-inch (38mm)*

Fan Brush
- *White sable no. 6*

Script Liner
- *No. 4 synthetic*

Paint Shaper
- *Flat chisel no. 2 Colour Shaper*

Palette Knives
2-inch (51mm) and 1¼-inch (31mm) trowels

Mahlstick

Most of the time when combining more than one photo or sketch for a painting, it's helpful to do a quick study to work out in advance any problems that may arise. Use any medium you're comfortable with—pencil, watercolor, oil, gouache, acrylic—whatever allows you to set out the basic elements you're dealing with. For this painting I chose an interesting image of a sheep with a mountain scene in the same general area.

Reference Photos
Unless you have a specific reason for doing otherwise, it's essential to use reference material with light coming from pretty much the same direction. You can get away with some inconsistency in the light sources, but if you push it too far—say, a sunset sky in the background with the foreground illuminated by direct sunlight from the right— you'll prompt a good many viewers to laugh or scowl, a reaction not conducive to good sales or winning awards.

1 | Quick Study

Do a quick study to understand how to combine the elements of the different photos—what to include, what to delete and any other changes to be made. Solving these matters on a small scale is usually much easier than trying to figure it all out in a full-scale work.

SHEEP STUDY
Acrylic on mat board
9" × 6" (23cm × 15cm)
Collection of the artist

2 | Sketch the Basic Shapes

With a ⅜-inch (10mm) bristle filbert, sketch the lines of the basic shapes using a no. 7 thin-consistency combination of Ultramarine Blue and Titanium White for the mountains and Raw Umber for the sheep and foreground. This step can be childishly simple. The important factor is proper placement of the shapes.

3 | Draw and Wash In the Sheep and Grass

Draw the sheep more carefully with a ¼-inch (6mm) soft bright. Because it is the center of interest, you want to make sure the sheep is accurately drawn in addition to properly placed. Use Raw Umber toned down with a touch of Payne's Grey for drawing it and washing in the shadow areas. At this stage the animal is still a bit indistinct. Don't panic. You'll firm it up as the painting progresses. For now the right placement and pose are all that are needed. On the other hand, if you are more at home carefully drawing the picture first with pencil to make sure everything is exactly right, then use that approach. Once the pencil drawing is complete, apply a thin coat of spray retouch varnish and allow it to dry before proceeding.

The foreground grass light areas are a thin wash of Yellow Ochre with some light green—a combination of Light Yellow, Terre Verte and a bit of Cream—added here and there, scrubbed on with a no. 10 bristle bright. The shadows in the grass are a no. 6 consistency mixture of Terre Verte and Raw Umber washed and scrubbed in with the no. 10 bristle bright and in smaller spots with a no. 4 bristle filbert.

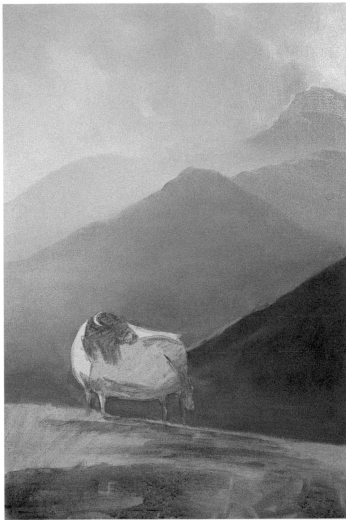

4 | Block In the Background

In most landscapes, working from the background forward makes painting the foreground detail much easier. Painting the grass and sheep's wool into and over the completed background is a much simpler task than doing the foreground first and trying to complete the background around all that detail. Use nos. 1 and 2 consistency paint for all the background, tip loading the paint and applying it at a medium to steep angle. Most of the background blending is partial and thorough wet-into-wet work. For the sky, mix varying combinations of Titanium White, Ultramarine Blue and Payne's Grey, adding more of the blue and gray for darker areas. For the light blue sky section in the upper left corner, mix a very teensy bit of Phthalo Blue with Titanium White. Watch that Phthalo Blue! This extremely potent color needs to be handled with care. Render the sky with a 1-inch (25mm) soft bright.

Use the same size brush for most of the painting of the mountains along with a ½-inch (12mm) soft flat or filbert for careful work along the edges. The colors to use are Ultramarine Blue, Payne's Grey, Terre Verte, Titanium White and Cream. The more distant mountains will use more blue, white and gray, and the nearer ones will have mixtures stronger in the green and yellow.

Detail

Use a medium-size soft-haired bright to paint the sky. Load with the tip-pull method and blend wet-into-wet.

Detail

To paint the light shining on the mountain sides, use a ½-inch (12mm) soft filbert loaded with the tip-pull method. Applying the paint at a fairly shallow angle will make it possible to lay down thicker strokes that catch the light.

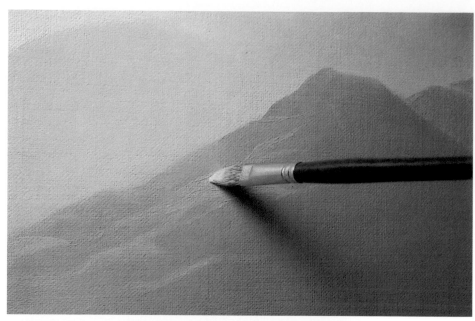

5 | Paint the Light Areas of the Mountains

Now it's time to paint the areas where sunlight strikes the mountain sides. Begin with the basic color you mixed for each mountain; lighten that color with Cream and Titanium White. The most distant peaks will need only a touch of yellow. For the nearest slope add a little Yellow Ochre in some spots. Apply the paint using ½-inch (12mm) soft flats and filberts working at a fairly shallow angle.

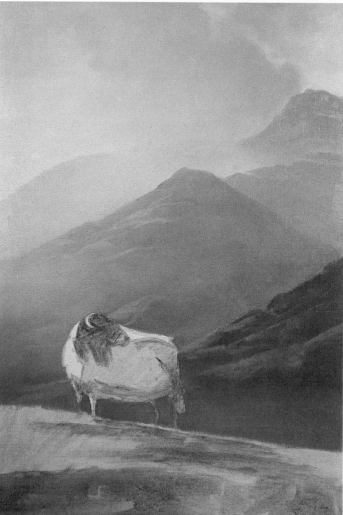

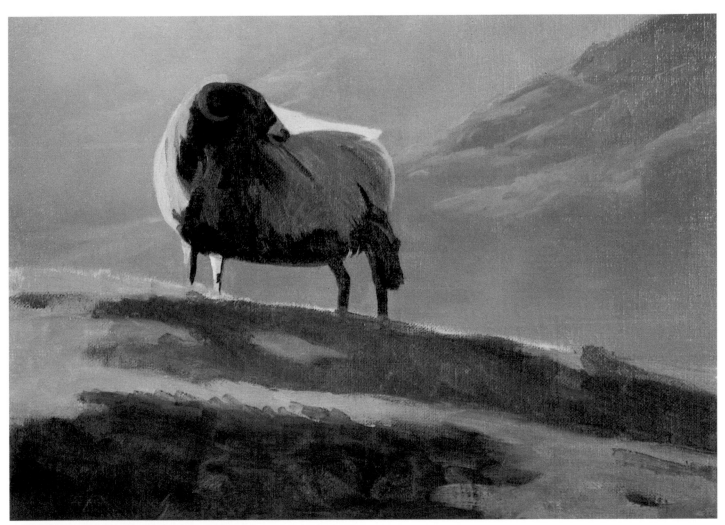

6 | Block In the Sheep and Foreground

With no. 1 consistency paint, block in the sheep and foreground.
For the sheep, mix various combinations of Payne's Grey, Raw
Umber and Titanium White and add a bit of Burnt Sienna for the
horn. Block in with a ¼-inch (6mm) or smaller soft bright. Complete
drawing the animal, doing the tightest work with a no. 8 soft round. With
the addition of Burnt Sienna in a few spots and Light Yellow in the lightest
areas, use the same colors for the foreground as in the wash-in stage,
but now use no. 1 consistency paint. Nearly all of the appearance of
blending in this stage and the following step is accomplished with
transitional colors.

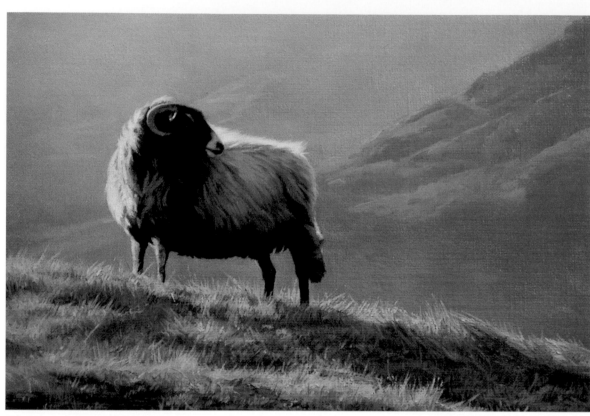

7 | Paint the Foreground Detail

If you've gotten by until this point without the mahlstick or pinkie, you'll need
them now to steady your hand. Most of the wool in shadow can be rendered
with the ¼-inch (6mm) soft bright using the shovel-tip-loading method.

 Even though the wool appears gray, it has some brown in it, so don't hesitate to work a little
Raw Umber into some areas. In fact, mix the Raw Umber with Ultramarine Blue for the darkest
passages. For variety, allow some strands to tend toward brown and others toward blue. The light-
est shadowed areas on the back and muzzle are reflecting a good deal of blue from the sky, so mix
in more Ultramarine Blue and Titanium White for those sections. There are warm accents in the
sunlit wool. In some places add a touch of Cream or Burnt Sienna with the white. Working with a
no. 1 soft round for the pickiest details of the horn and wool, eye and muzzle, pick up the paint with
chisel tip loading for lines and point loading for small areas.

 At first glance the grass appears to be very detailed, but it's simply a matter of a whole bunch of
thin short strokes. Chisel the tip of a good ¼-inch (6mm) soft bright or flat and shovel load or chisel
tip load the pigment to paint the thin blades. If you're more comfortable using the no. 1 soft round
for some of the smallest blades, by all means go at it. Be patient and it won't be that difficult. The key
is getting the sunlit grass to form patterns and clumps that appear to follow the contours and folds
of the ground. The brightest sections are a mixture of Lemon and Titanium White. Paint some of
the orangish blades with white, Yellow Ochre and a touch of Burnt Sienna. For the greenest patches
mix Terre Verte with Lemon. In the shadows work with Terre Verte and Raw Umber with an addi-
tion of Ultramarine Blue in the cooler sections. In the reddest shadow and shine-through spots,
combine Burnt Sienna with Cream or Yellow Ochre. You can even use accents of Red in a few
blades.

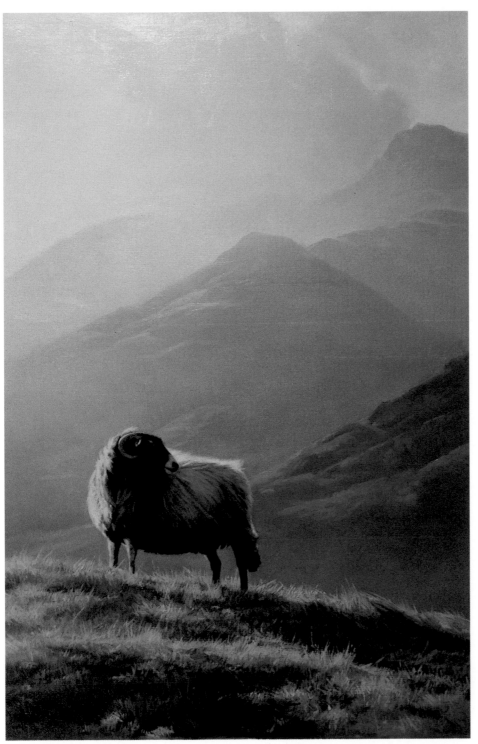

8 | Changing the Background

Woops! The background is a little too weak in comparison to the strong contrasts and detail of the foreground. It needs to be darkened and made a bit more prominent to balance the strong foreground. This is just a normal part of the creative process. Since the background is already dry, you'll have to repaint, glaze and scumble your way out of this one. Rework the most distant mountains to make them stand out more. Slightly darken the middle mountain and subtly increase the sunlight on its left slope. Darken the clouds and add more blue sky to the upper left corner.

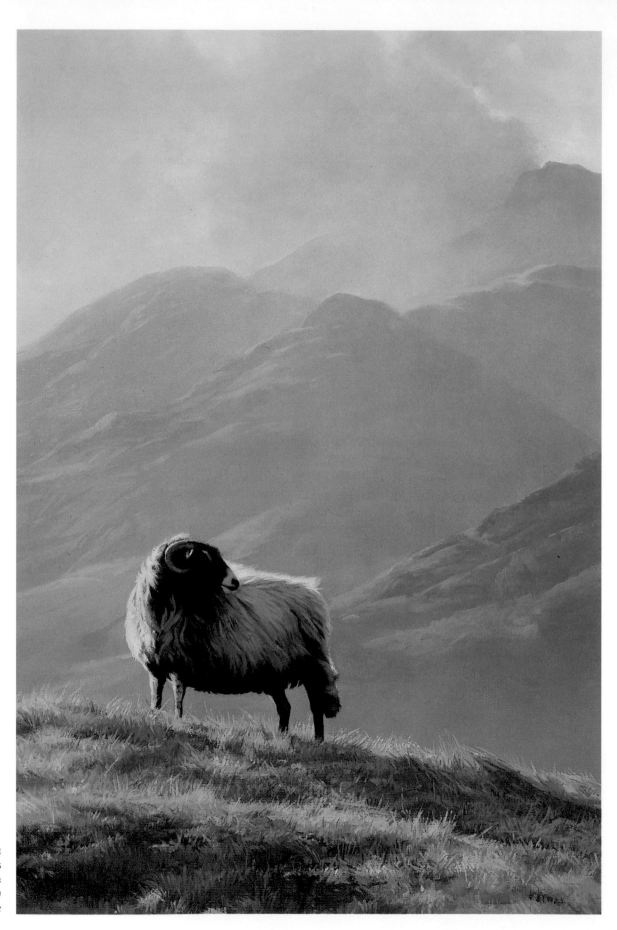

CALL OF THE
MOUNTAINS
Oil on canvas
24" × 18" (61cm × 46cm)
Collection of the artist

The Figure

MATERIALS LIST

Holbein Duo Aqua Oils
Base Palette
- *Burnt Sienna*
- *Cream (Naples Yellow)*
- *Light Yellow (Cadmium Yellow Light Hue)*
- *Madder*
- *Marine Blue (Phthalo Blue)*
- *Payne's Grey*
- *Raw Umber*
- *Terre Verte*
- *Titanium White*
- *Ultramarine Blue*
- *Yellow Ochre*

Accessory Palette
- *Burnt Umber*
- *Cobalt Blue*
- *Green*
- *Lemon*
- *Mars Black*
- *Navy Blue (Prussian Blue)*
- *Red*
- *Yellow (Cadmium Yellow Medium Hue)*

Mediums
Water

Winsor & Newton Artisan Water Mixable
 Linseed Oil

Brushes
Synthetic Bristles
- *Flats nos. 4–10*
- *Brights nos. 4–12*
- *Filberts nos. 4–8*

Soft Synthetics
- *Rounds nos. 1, 2 and 8*
- *Flats ¼-inch (6mm) and ½-inch (12mm)*
- *Brights ¼-inch to 1-inch (6mm–25mm)*
- *Filberts ⅛-inch to 12-inch (3mm–300mm)*

House Painting Brushes
- *1-inch (25mm) and 1½-inch (38mm)*

Fan Brush
- *White sable no. 6*

Script Liner
- *No. 4 synthetic*

Paint Shaper
- *Flat chisel no. 2 Colour Shaper*

Palette Knives
2-inch (51mm) and 1¼-inch (31mm) trowels

Mahlstick

The difference between portrait painting and regular figure work is that a portrait requires the picture to resemble the subject as closely as possible, while regular figure work is not so restrictive in copying the sitter's appearance. Since this is not a portrait, you don't need to strive for an exact likeness of the boy.

Because I've included several paintings with candles and lanterns in the book, I thought it only fair to do a figure demonstration with that sort of subject. Painting from candle and lantern light has its own set of challenges. Unless you're quite the photographer, you can't rely on the colors and contrasts from photos you take. If you choose to paint these low-light scenes, you'll need to be prepared to work from life. First, you must block all light from your studio windows with thick shades, curtains or shutters. I have installed shutters inside my studio. Next, set up a light that adequately illuminates your painting but interferes as little as possible with the scene you set up. Even with a careful placement of your lamp, you'll still need to frequently turn it off to study the tricky, subtle colors of candlelight, so have the lamp's switch near at hand or use an extension cord with an in-line switch so that you can readily flip it on and off.

Reference Photo

It's helpful to eliminate a lot of visually distracting clutter in the background by arranging an old blanket or sheet as a backdrop. Have every possible element set up before you pose the model; he or she isn't going to be too keen on sitting around in position while you arrange this or that detail for the scene. The subject in the reference photo has the proper degree of light and contrast, but the lamp is overexposed. To get the lamp right, it's necessary to work from life as I described earlier.

1 | Sketch and Wash In the Basic Shapes

Establish the placement of the figure, table and lantern by sketching them in with a ¼-inch (6mm) soft-haired bright using Burnt Umber thinned to no. 6 consistency. Pay special attention to the drawing of the face and lantern. Wash in the shadow areas with a no. 10 bristle bright to see how the painting balances at this point. Use Burnt Umber for most of the washes, and for the darkest places add a bit of Ultramarine Blue.

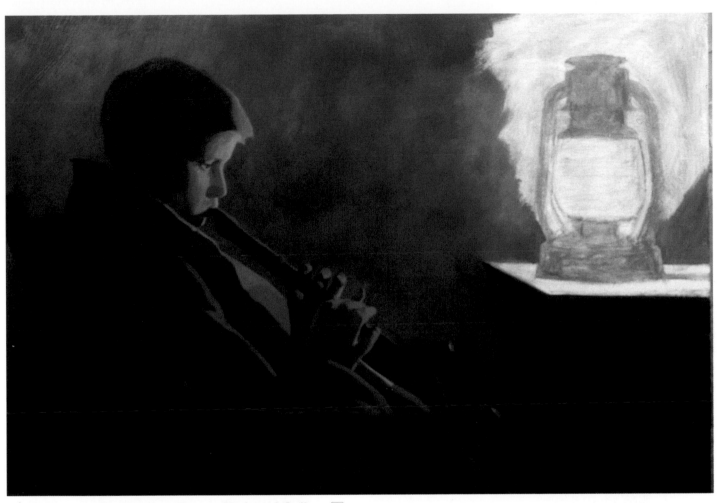

2 | Block in the Background, Figure, Chair and Quilt

Because the lantern is of secondary importance to the figure and because the background behind it will need to be subtly blended with lighter and warmer colors, ignore those two elements for now just so long as the lantern is properly placed and drawn. Since we're painting on a smooth gessoed panel, it's necessary to work from here on out with soft-haired brushes. The bristles deserve a rest anyway.

Paint the wide open spaces of the background using a no. 3 consistency mixture of Raw Umber, Ultramarine Blue, Cream and Burnt Sienna, with a ¾-inch (19mm) to 1-inch (25mm) soft-haired bright. Primarily use the tip-pull-loading and side-to-side blending methods. Use a ⅜-inch (10mm) soft bright to carefully paint the background up to the edges of the objects.

Block in the boy, quilt, flute and chair using no. 2 consistency paint for everything. Use a ½-inch (12mm) soft bright for the shadows and ¼-inch (6mm) soft brights for the light areas. Even though you're only blocking in, carefully blend the transitions of light to dark using a 90-degree brush-to-canvas angle and touching with the very tips of the soft brights. If the paint dries before you get around to blending the transitions, trying to do smooth blending over sharp-edged contrasts can be difficult.

For the light skin tones, mix Cream, Red, Burnt Sienna and Yellow. At the transitions of light to dark on the face and hands, add Madder with a

bit of Burnt Umber. Because the lantern light is very yellow, pay attention to keeping the light skin tones warm. Use Raw Umber, Burnt Sienna, Ultramarine Blue and a touch of Yellow Ochre for the flesh shadow. The back of the right hand is receiving reflected light from the quilt; use Red with more Yellow Ochre to lighten and warm it.

Just adding Red to Burnt Umber and Ultramarine Blue will lighten the shadows of the red patches of the quilt too much. Instead use Madder, a much darker yet potent red, in combination with Raw Umber, Ultramarine Blue and only a touch of Red. The Raw Umber and the touch of Red will actually provide all the lightening of tone that's needed. Mix the dark blue patches from Ultramarine Blue with a bit of Burnt Umber. For the light patches, mix Raw Umber, Ultramarine Blue and a very little Cream.

As with the skin, the lighted areas of the quilt are a lot warmer than you'd expect. Paint the red highlights with Red combined with Yellow and Cream. At their transitions into shadow, add Madder and Burnt Umber. Mix the light quilt highlights from Yellow Ochre, Cream and Red.

Paint the darkest areas of the chair, flute, quilt folds and the boy's hair using Burnt Umber and Ultramarine Blue and lightened, where needed, with Raw Umber or Burnt Sienna.

Detail

Using the smooth blending technique with a ¼-inch (6mm) soft bright, gently lighten the boy's forehead and cheek.

3 | Paint the Details of the Face, Hair, Hands, Flute and Quilt

The colors from the previous step are used for the detail work. Just be careful in the lightest spots to include extra Yellow to harmonize them with the lantern flame.

Complete the modeling and shading of the face. Rendering all the subtle blending in the face is crucial to capturing the effect of the soft glow of lantern light. Work with ¼-inch (6mm) and ½-inch (12mm) soft brights and use the smooth blending technique to create a very gentle transition on the cheek and forehead from light to dark. As you blend that transition, add extra Madder to the light side as you near the shadow. For the most careful detailing in the hands and face, especially for the eyes and nose, use no. 1 soft rounds working with just their tips.

For the small, bright reflections in the eye, on the nose and on the fingertips, as well, use a no. 1 soft round to point load small dabs of pigment—no. 2 consistency mixtures of Titanium White with Light Yellow—and carefully touch the paint to the canvas. With a mixture of Yellow, Burnt Sienna and Titanium White, use the same method for painting highlights on the flute.

Employ the chisel-tip-loading technique using a ¼-inch (6mm) soft bright, flat or filbert to paint all the thin straight lines in the hair and flute and in the thinnest areas of light on the quilt.

Most of the pattern details of the quilt patches in shadow do not need to be exact and can be suggested by using a ¼-inch (6mm) soft bright. The lone exception is the polka dots on the dark blue squares, which can be painted with a no. 1 soft round.

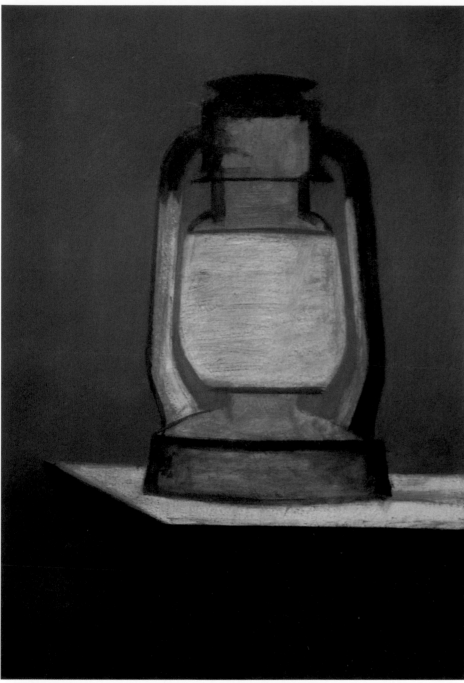

4 | Outline the Lantern and Paint the Background

Carefully outline the lantern with a no. 2 consistency mixture of Terre Verte, Raw Umber and Ultramarine Blue. Use a ¼-inch (6mm) soft bright and a no. 8 soft round for the outlining.

 To enhance the impression of light glowing from the lantern, gradually lighten and warm the background with Burnt Sienna and Cream as it nears the glass chimney. Employ the smooth blending method using ¾-inch (19mm) to ½-inch (12mm) soft brights held at a steep angle with only the hair tips touching the paint. Be careful to avoid forming a paint ridge around the lantern.

5 | Block In the Lantern and the Table

As indicated earlier, the light areas of the lantern are overexposed in the reference photo. You'll have to buckle down and work from life or follow my lead.

Paint the shadows of the lantern body using a no. 2 consistency mixture of Terre Verte, Ultramarine Blue and Raw Umber. The lighted areas are combinations of Terre Verte, Cream, Yellow and Raw Umber. Paint the large areas with a ½-inch (12mm) soft bright and use the old reliable ¼-inch (6mm) soft brights to paint the narrow sections.

Paint the lantern's chimney a little lighter and a lot warmer than the background. Paint the flame with straight Titanium White, adding some Yellow only at the edges. When it's dry, you'll glaze a thin coat of Light Yellow over the white to get the most luminous yellow possible for the flame. For easier blending in the darker parts of the chimney, use no. 3 consistency mixtures of Burnt Sienna, Cream and Raw Umber with a touch of Red. Paint the lighter areas around the flame and the reflections using combinations of Burnt Sienna, Cream, a greater proportion of Red with the addition of Yellow and Yellow Ochre. The soft glow around the flame requires careful smooth blending.

For the light areas of the tabletop, use a mix of Burnt Sienna, Yellow Ochre, Raw Umber and Cream. The shadow can be painted with a combination of Raw Umber, Ultramarine Blue and Burnt Sienna. Use ½-inch (12mm) and ¼-inch (6mm) soft brights.

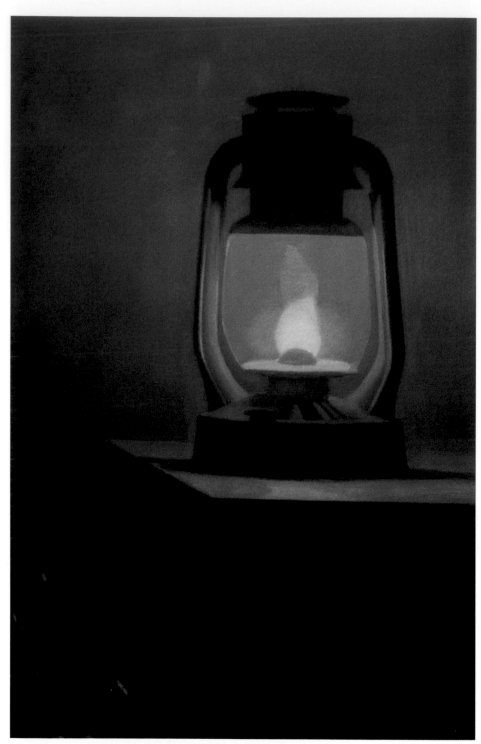

6 | Paint the Intermediate Shapes in the Lantern

Use the same brushes as in the previous step with the addition of no. 1 soft rounds for the tightest detail. The same color combinations can be used to paint the grooves and ridges of the lantern body and the reflections in the chimney.

Paint the metal hoops around the chimney with a no. 1 soft round. The sections that pass in front of the flame should be an orangy light Burnt Sienna color. The light sections of hoop behind the flame achieve their slight green tone not from having any actual green in them but just by being less red than the surrounding paint. Add the various levers.

Refine the blending of the glow in the chimney and on the light areas of the body.

7 | Paint Final Highlights and Details and Glaze the Flame

All sorts of shiny reflections are on the lantern body and within the chimney. The light effect will be dramatic when you add these.

The final details are painted with a no. 1 soft round using the chisel-tip-loading method for linear strokes and the point-loading method for small touches of paint. Use a mahlstick or your little finger to steady your hand for this delicate work. Mix a no. 1 or 2 consistency combination of Yellow, Titanium White and just a touch of Terre Verte for the highlights on the metal body.

Paint the flame adjuster loop, the cap loop and the little bit of lantern handle peeking out from behind the right of the lantern.

Paint the lightest reflections in the chimney using a mixture of Yellow, Titanium White and a touch of Red.

Finally, thinly brush a no. 3 consistency glaze of Light Yellow over the white of the flame. Use only a very little bit over the center of the flame and slightly more at the edges.

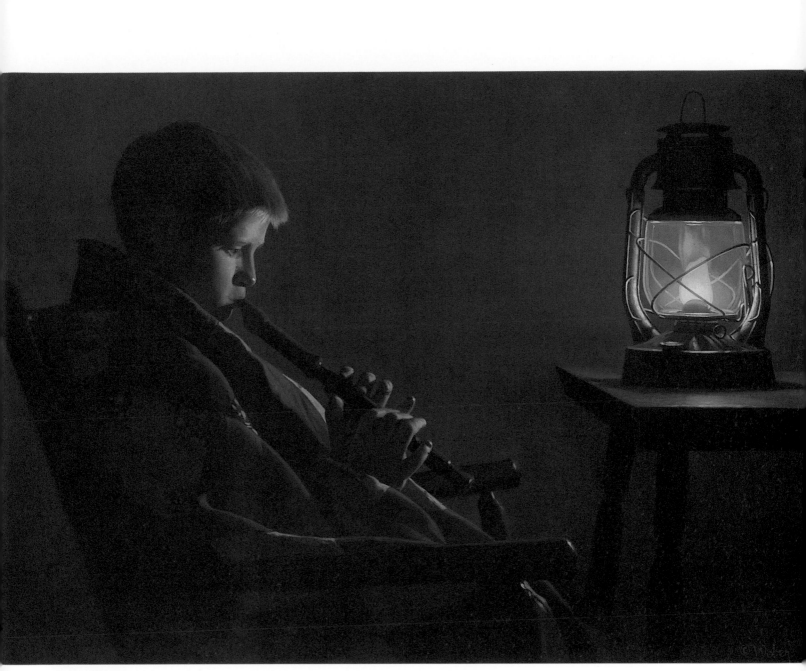

QUIET TONES
Oil on panel
20" × 28" (51cm × 71cm)
Collection of the artist

Gallery of Work

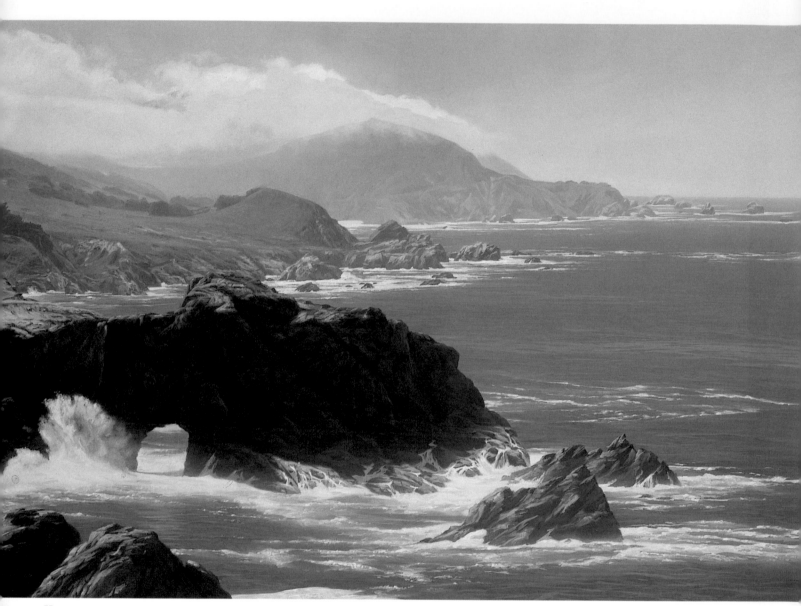

HEADLANDS
Oil on panel
16" × 24" (41cm × 61cm)
Collection of Christo and Sara Bardis

<div align="right">

AT THE WINDOW
Acrylic on panel
20" × 16" (51cm × 41cm)
Collection of Seymour and Shirley Zeinfeld

</div>

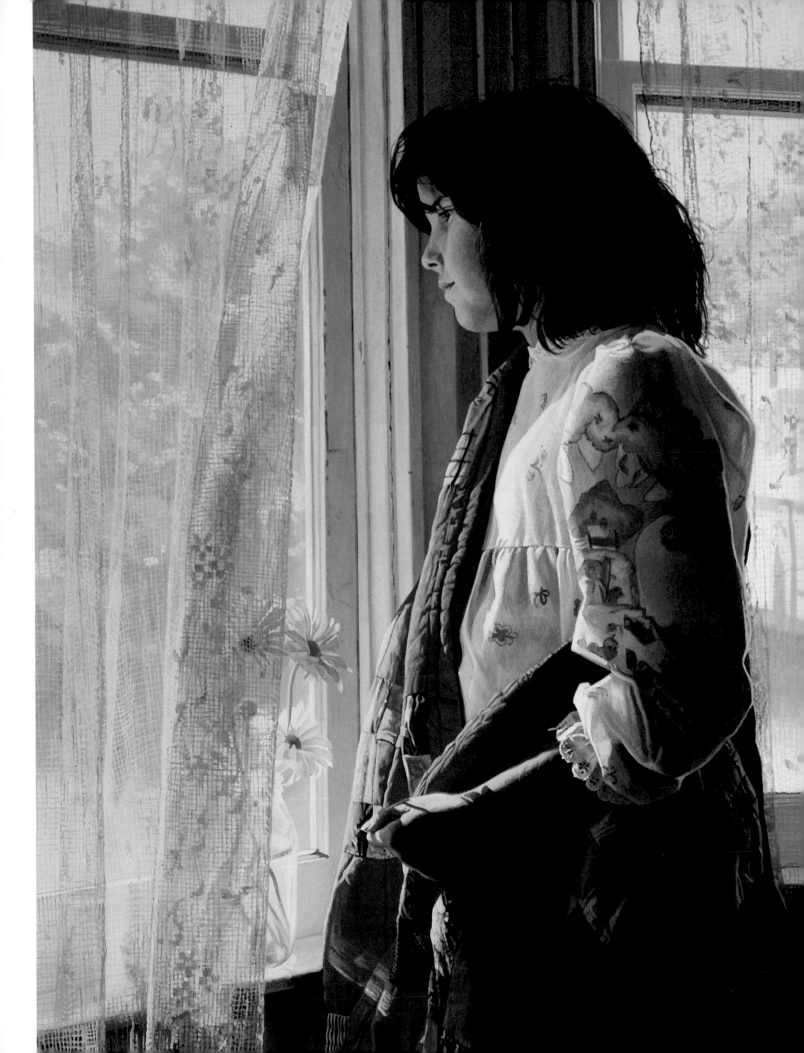

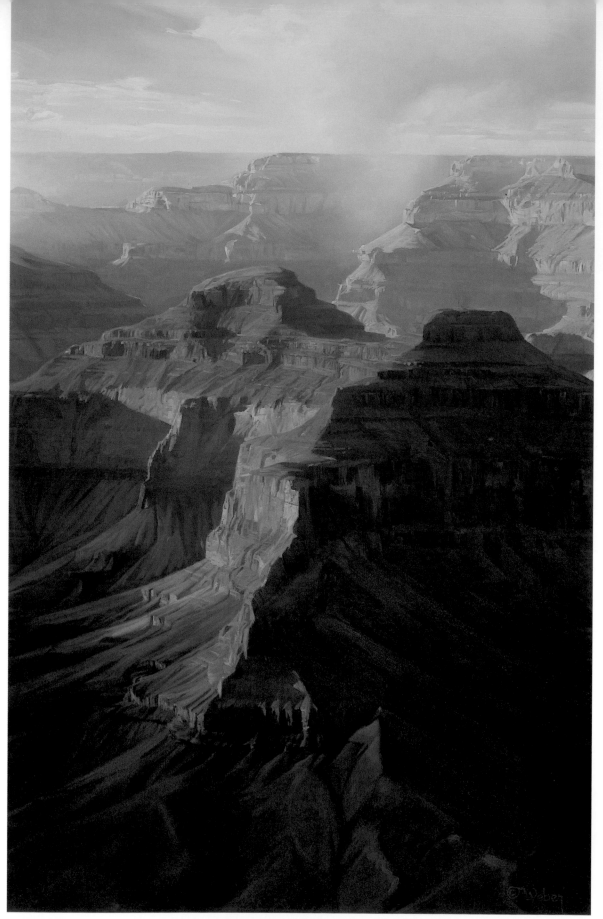

CANYON DRAMA
Oil on canvas
36" × 24" (91cm × 61cm)
Collection of Larry and Kathy Luke

JOHNSON GREENSHIRT
Acrylic on panel
20" × 16" (51cm × 41cm)
Collection of the artist

CLOSING WORD

Before this point you've probably asked yourself, how should each of these strokes be employed in any particular painting or effect? This is the easy part for me and the real challenge for you. One of the great things about oil painting is that there is no one way—no one hundred ways—things should be done. I've seen very similar effects achieved by different artists using very different means.

Why? There's just something about this art stuff that causes us to dig out all our creative abilities. We just can't help ourselves. We may start out saying, "I want to paint just like Bob So-and-so." But by the time we've mastered a lot of what old Bob can do, we've said several times, "Hey, now! If I do it like this instead... Cool!" Then we're off on our own track. (Of course, plenty of times it's more like, "Hey, now! If I do it like this... Aw, man! Where's the rag?")

This is all part of how each competent artist's work becomes wonderfully unique. The creative bent that led us into painting in the first place sees a happy accident or a new possibility and plows joyously ahead.

The basic techniques demonstrated in this book provide a foundation designed to enable you to spread your wings and explore new horizons as you learn on your own. So this, friend, is where my adventure ends and yours begins.

Sing the Morning Sun
Oil on panel
30" × 40" (76cm × 102cm)
Collection of the artist

INDEX

Explore Oil Painting With North Light Books!

Frank LaLumia shows you how to envision nature's essence and capture it on paper and canvas. You'll learn the basics of rendering natural light and color properly, how different paints can affect your plans and how fluency in the language of painting allows you to capture the extraordinary, magical happenings in the world beyond your window.

ISBN 0-89134-974-X, HARDCOVER, 128 PAGES, #31666-K

Master painter Kevin Macpherson shares his techniques for capturing the mood of a scene in bold, direct brushstrokes. His step-by-step instructions make it easy—simply a matter of painting what you see. In no time at all you'll be creating glorious oil landscapes and still lifes that glow with light and color.

ISBN 1-58180-053-3, PAPERBACK, 144 PAGES, #31615-K

John Howard Sanden teaches you how to create beautiful portraits of real people by breaking down the process into 29 logical steps. Working in the exciting premier coup tradition, you'll learn to execute a finished portrait in a single sitting, starting with your very first stroke. Sanden's comprehensive method will help you create convincing, lively portraits every time.

ISBN 0-89134-902-2, HARDCOVER, 144 PAGES, #31434-K

Here's the information you need to master the exciting medium of water-soluble oils! You'll learn what water-soluble oil color is, its unique characteristics and why it's generating so much enthusiasm among artists! Water-soluble oils make oil painting easier and more fun than ever before, plus you get gorgeous results. You may never go back to traditional oils again!

ISBN 1-58180-033-9, HARDCOVER, 144 PAGES, #31676-K

These books and other fine North Light titles are available from your local art & craft retailer, bookstore, online supplier or by calling 1-800-221-5831.